SAN MARINO

UMBRIA

Stia

Florence

San Casciano

fioralle Greve
Casole
Panzano

Volpaia

Castellina

Ambra

Montebenichi

Arezzo

Petroio

C A N Y

Monteriggioni

Castelnuovo
Berardenga

Lucignano Cortona

Siena

Manzano

*Lake
Trasimero*

Montisi Castelmuzio

Buonconvento

Montepulciano

Monticiano

Pienza

Montalcino

Montichiello

MARCHE

Radicofani

Ombrone

Grosseto

Sorano

Scansano

Pitigliano

*Lake
Bolsena*

0 25 mi
 40 km

A PHOTOGRAPHER'S JOURNEY

TUSCAN COUNTRY

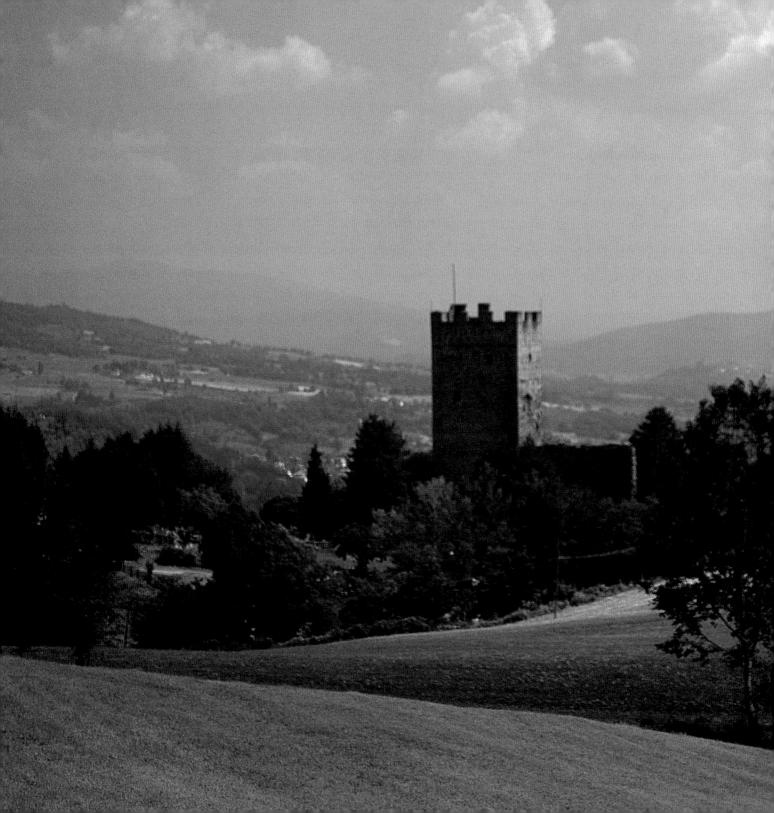

A PHOTOGRAPHER'S JOURNEY

TUSCAN COUNTRY

WES WALKER

INTRODUCTION BY PIERO ANTINORI

welcome
BOOKS

NEW YORK • SAN FRANCISCO

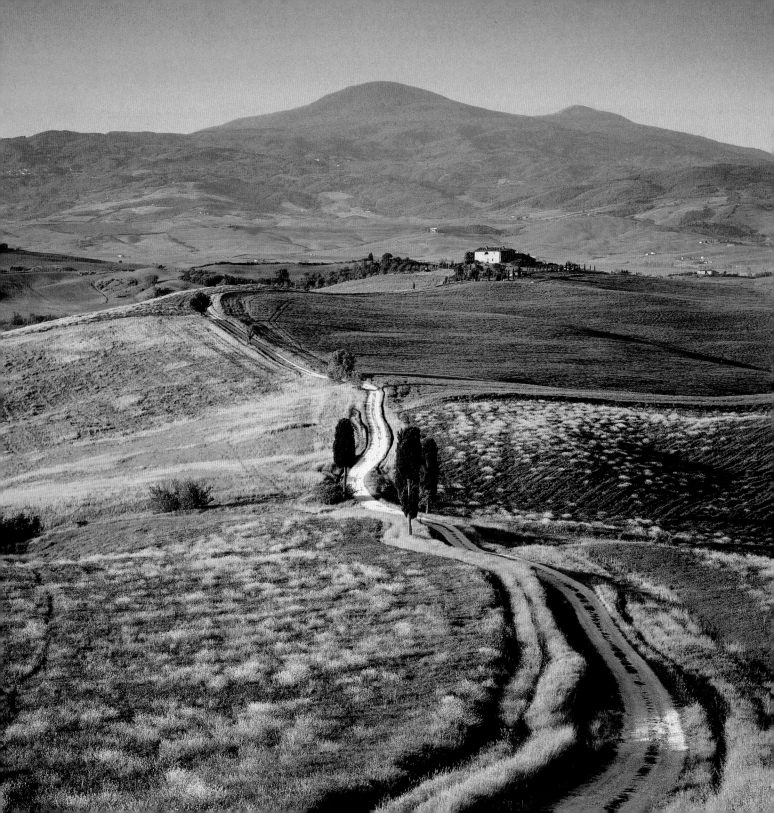

FOREWORD

There are few places in the world where the beauty of the landscape and the imprint of the people merge to create something as special as Tuscany.

I have attempted to capture with my camera the essence of this beauty, from fields of red poppies and emerging wheat in spring . . . to profusions of sunflowers and rolls of wheat straw in summer . . . to vineyards ablaze with color in fall. This is a land steeped in art, spawned during the Renaissance, evident in the smallest of *cappella*s and the grandest of *duomos*; in architecture, with stone houses and their attendant places of worship stacked one atop another on the hilltops and promontories; in the cultivation of vineyards and crafting of world-class wines; in history, dating back to the Etruscans and the Romans; in the never-ending olive orchards and their savory oil; in wonderful Pecorino cheeses, the product of the sheep grazing on the verdant fields of alfalfa in spring. These patchwork fields of wheat, corn, grapes, and sunflowers, seemingly chaotic, have a certain simplicity and order. These are just some of the parts that make up the whole and infuse Tuscany with its splendor.

PAGE 1: Wheat field and sky near Manzano.

PRECEDING SPREAD: The medieval town of Stia guards the source of the Arno river, and is home to the ruins of the Castello di Porciano, shown here rising above the treetops. The tower was once a Guidi stronghold, guarding the narrow Arno Valley in the tenth century.

OPPOSITE: Traveling south from Pienza through the Orcia Valley, my wife, Marsha, and I came upon the picturesque Terrapille. Available for renting year-round, this 15-bedroom farmhouse looks out on Mount Amiata, and was used to shoot scenes from the movie *Gladiator*.

My wife, Marsha, and I traveled for more than three months—in three different seasons—seeking out rural Tuscany. We visited the well-known hilltop villages as well as those hidden away in the rolling countryside and in the valleys cutting into the mountains, from the Alpuane Alps in the north to Mount Amiato in the south. We found not only spectacular scenery and architectural charm but also warm and genuine people living in an environment seemingly unchanged over the centuries.

We will never forget following a troupe of musicians and flag throwers to a wedding anniversary in a small chapel in Suvereto celebrating the life of an aged couple; sliding down a steep hillside in the chestnut forest at Villa Arceno with Eric, an old friend, gathering chanterelles that his wife, Valeria, made into a delicious pasta that evening; looking on as Lucia, our hostess, cast grain to her chickens and geese early in the morning at Agriturismo Terrapille; finding a cruet of golden-green oil on our kitchen table harvested from the olive trees in front of our apartment the day before by her father, Giuliano; marveling at the frescoes at Sant'Anna di Camprena, where Sodoma perfected his art before completing the murals started by Signorelli at Monte Oliveto Maggiore; listening to a choir practice at the Duomo San Francesco in Arezzo, filling the acoustically perfect cathedral with glorious sound; meandering the fields with Antonia, a gifted cheeesemaker, to photograph her Sicilian sheep (source of her delicious Pecorino cheeses) and dining in the family home built centuries before; taking pictures in Lucignano of an older woman in a print dress with a small basket of raspberries in her lap (which she then offered to us); climbing into the marble quarries near Carrara and studying the crystalline white stone—raw material for some of the world's finest art; bumping down a staircase in our Peugeot on a steep narrow street in Cortona with two women looking on in disbelief; walking with our host Ivano through a centuries-old wine cellar at Castello di Gabbiano; trying to keep up with

Barbara, our guide, as we toured the grand Antinori estates from Tignanello to Guado al Tasso and walking through the vineyards where grapes for the family's famed Solaia wine were grown.

The genesis of our travels and this book can be found in our roots in the Napa Valley, where we have farmed the land and grown Cabernet Sauvignon grapes for Silver Oak Cellars for many years. Our grower and vintner friends here generously provided access to their vineyards and wineries for our first book, *Hidden Napa Valley*. It was serendipitous that for this book, we should move on to Tuscany—a similar land, but one steeped in centuries of history and tradition. Our friends in Napa introduced us to the Antinori family, Ivano Reali, Emanuela Stucchi-Prinetti at Badia a Coltibuono, and Valeria Bottazzi; all provided us extraordinary access to their estates and cellars, and we owe them many thanks.

As we traveled, we stayed primarily at *agriturismos*—beautifully restored old sharecroppers' stone houses in the countryside—and ate at small trattorias and *osterias* in the villages, many of which are included in the resource guide. We wandered at dawn and sunset through the fields of newly cut wheat raked into rows before being rolled, and into meadows of sunflowers seeking out the light for the perfect image. We were awestruck with the beauty of the grand *duomos* and the small *pieves* throughout the countryside. Medieval towns encircled by protective walls and crisscrossed with narrow streets provided a constant adventure, their small shops and restaurants perfect subjects for a traveling photographer.

For all who love good food, fine wine, ancient villages, pastoral countryside, and engaging, warm people, find your way with us to the hilltops and valleys far away from the large cities of Tuscany . . . and enjoy!

INTRODUCTION

Tuscany: a magnificent name and a picturesque place. Every time I travel, I realize the magic this region evokes and the emotions it arouses.

Indeed, ours is a wonderful part of Italy. Perhaps more than any other region in the world, it contains in itself a long history—from the Etruscans to the Romans—an extraordinary tradition, a unique culture, an incomparable natural beauty, and an exceptional variety of landscapes. Our wines are as distinctive as the place; the bounty of our land provides us with a variety of other high-quality foods such as olive oil, cheeses, and cured meats; and our gastronomy has achieved great fame worldwide.

Tuscany is, above all, the region where the Renaissance was born. In this relatively brief historical period, Tuscany saw a concentration of geniuses in fields from painting to sculpture, from architecture to the humanistic arts, from sciences to philosophy, and from astronomy to politics. Leonardo da Vinci is by all means the genius of geniuses of the Renaissance.

Its capital is Florence, a city that has radiantly projected its light on the rest of the world for countless centuries.

But Tuscany is not only Florence. It also is Siena, Lucca, Pisa, and other smaller cities and villages that all preserve their beauties intact. Montepulciano, Cortona, Pienza, San Gimignano, Montalcino, and Volterra are only a few of the glorious communities that make up the heart of Tuscany.

To capture this spirit and this soul in photographs is certainly not easy. Yet Wes Walker has succeeded in revealing here his artistic sensibility toward our countryside and, above all, his deep knowledge and his love for our region.

—PIERO ANTINORI

The wine cellar at Antinori's Tignanello Estate is famous for its Tignanello and Solaia vineyards, and is situated between the Greve and Pesa valleys in the heart of Chianti Classico region.

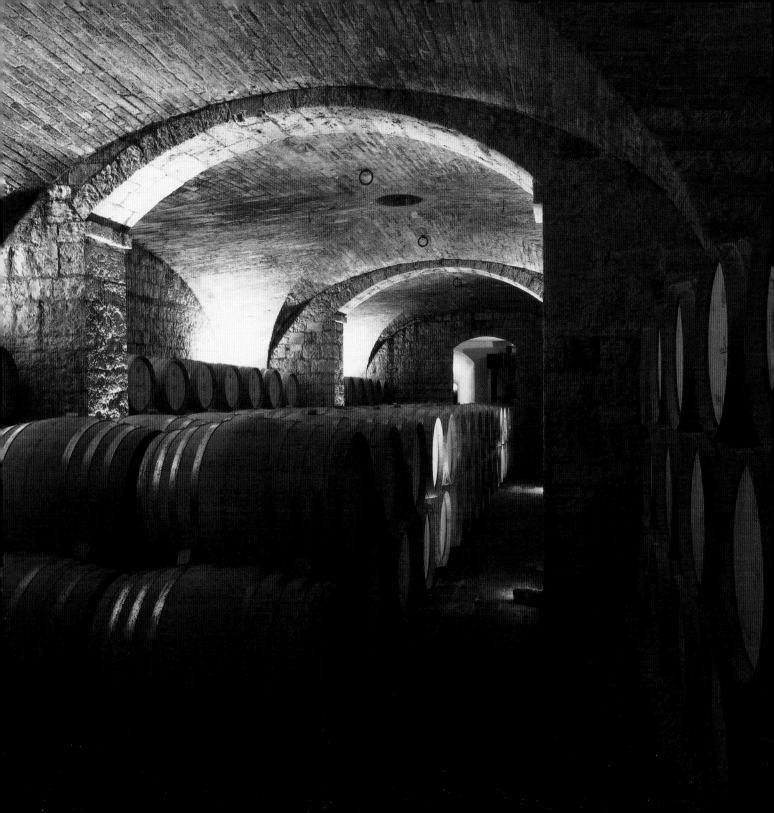

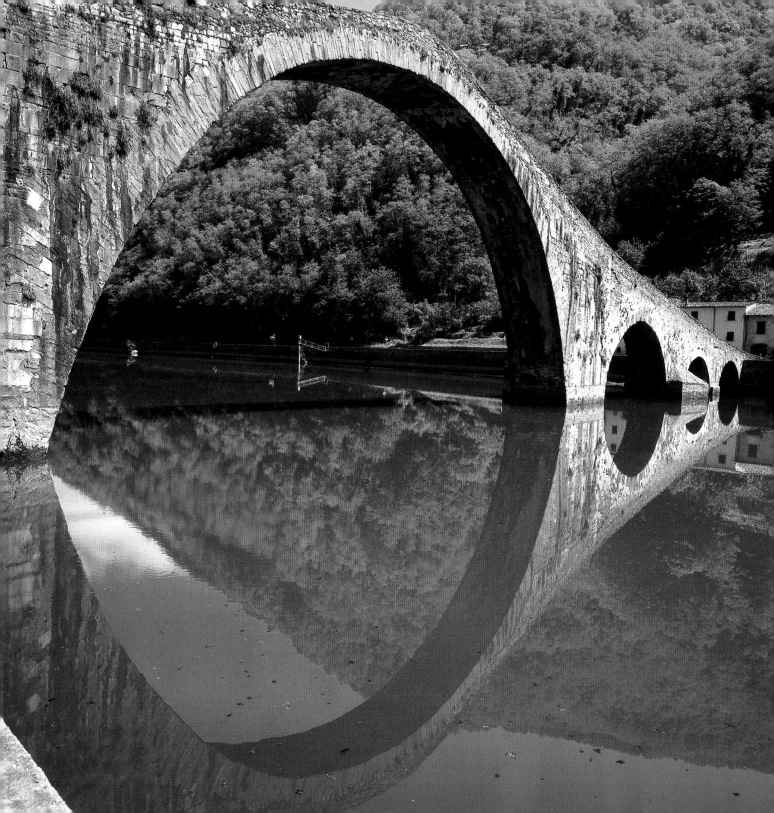

I

NORTHERN TUSCANY

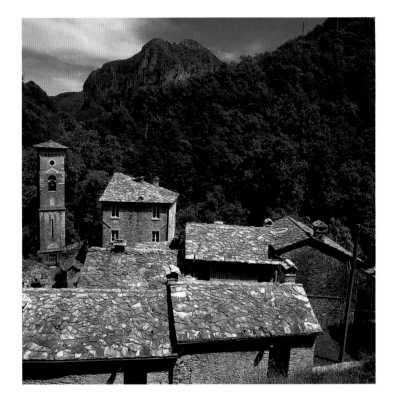

PRECEDING SPREAD: Traveling along the river Serchio past Borgo a Mozzano, we came to the *Ponte del Diavolo*—Devil's bridge—built by the Countess Matilda of Tuscany in the early eleventh century. The name attests to a local legend that the Devil built the bridge for the villagers of Borgo a Mozzano in exchange for the soul of the first person to cross it—but was outwitted when a dog was sent across in the night instead. The bridge remains a beautiful and whimsical sight with its five arches, each differing in shape and size.

ABOVE: Marsha and I came upon the all-but-abandoned village of Isola Santi while traveling through the Apuan Alps from the larger town of Carrara. The ancient houses and rooftops—constructed of local slate—rest amid Alpine greenery at the foot of a small lake, making the town a restful oasis within the otherwise rugged terrain. We followed a hiking trail leading up the slate slopes to the top of the ridge, and to the north the marble quarries of Carrara came into view. From these quarries came the fabulous white marble used by Renaissance sculptors to create some of the greatest works of art in the Western world.

OPPOSITE: A view of how deeply isolated Isola Santi is amid the surrounding mountains. Once a hideout for medieval renegades, the village now stands largely abandoned save for a few elderly residents and the sheep rumored to be living behind the altar of the church. We lunched at a small roadside trattoria nearby, enjoying a remarkably fine glass of *vin ordinaire* and pasta with pungent black truffles for less than six euros.

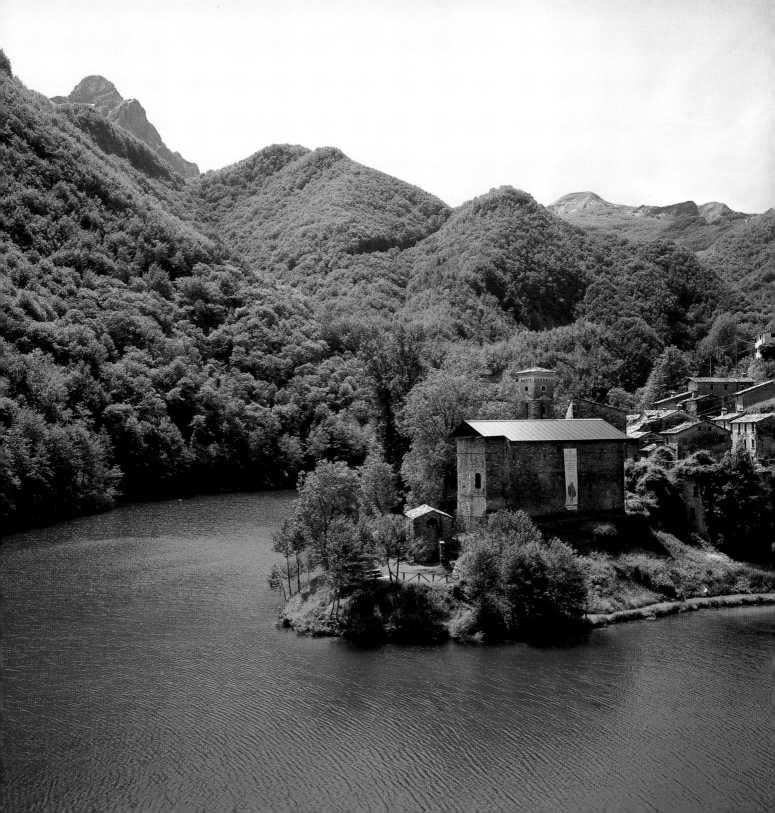

Lucca's second major piece of sorcery is the façade of San Michele, too tall for its church, which was meant, centuries ago, to be enlarged and heightened. The thirteenth-century ornamentation of the façade was added and added to, until now it is an overlarge, irrepressible giggling thing, and enchanting. It has no caution or restraint or modesty but, like a child dressing up out of a trunkful of clothing and costume jewelry, puts on everything. The base is fairly sober, a matter of tall blind arches in which are imbedded the commonly seen recessed stone diamonds. Then, the soaring of four orders of slender columns, each determinedly different from its neighbors; some writhe, a few are knotted, some swirl, a few limit themselves to geometric patterns in zigzags or diagonals, others take on zoosful of animals in singles, doubles and heaps, and when there seems to be no room left for the thinnest breeze to enter, a few columns shed forms like bark dripping from trees. Saint Michael and two angels stand at the summit to call a stern halt to the dervish dance of decoration.

KATE SIMON

The San Michele in Foro is one of the most breathtaking churches in Lucca. Built on the site of the old Roman forum, the facade is a spectacular example of Pisan Romanesque architecture. The four stories of arcades are decorated with inlays of green and white marble, and each column is unique—some doubled, some twisted like corkscrews, inlaid with mosaic work, and carved with fanciful figures and beasts. The *Madonna* that graces the corner is by Luccan sculptor Matteo Civitali. Just visible atop the facade is the Archangel Michael slaying the dragon, flanked by two angels.

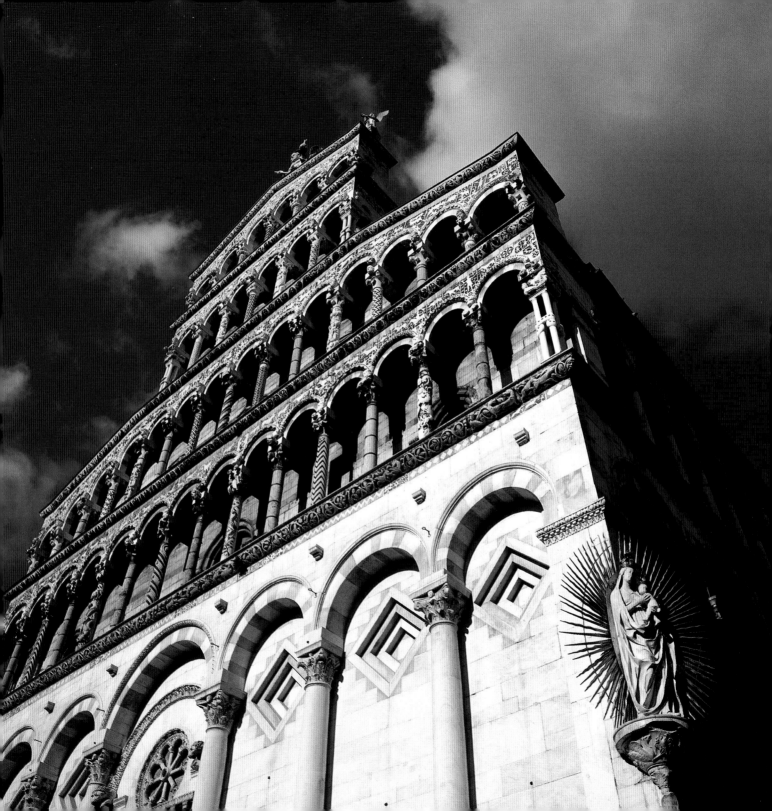

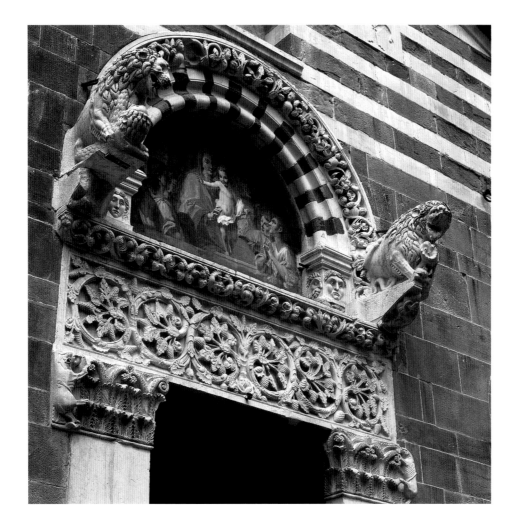

ABOVE: The church of San Giusto stands just northeast of the Piazza Napoleone in central Lucca. Built in the twelfth century, the facade is mainly sandstone with horizontal bands of marble. The richly decorated doorway, shown here, leads to an interior that was remodeled in the Baroque style in the mid–seventeenth century. While I was taking pictures of the church, Marsha came across Franco Montinelli, a remarkable men's clothing store nearby with linen shirts handmade on the premises—another item for the suitcase.

OPPOSITE: The interior of the church of San Giusto features a great amount of natural light around the altar. I found this quite a contrast with many of the dark, austere Tuscan cathedrals we visited.

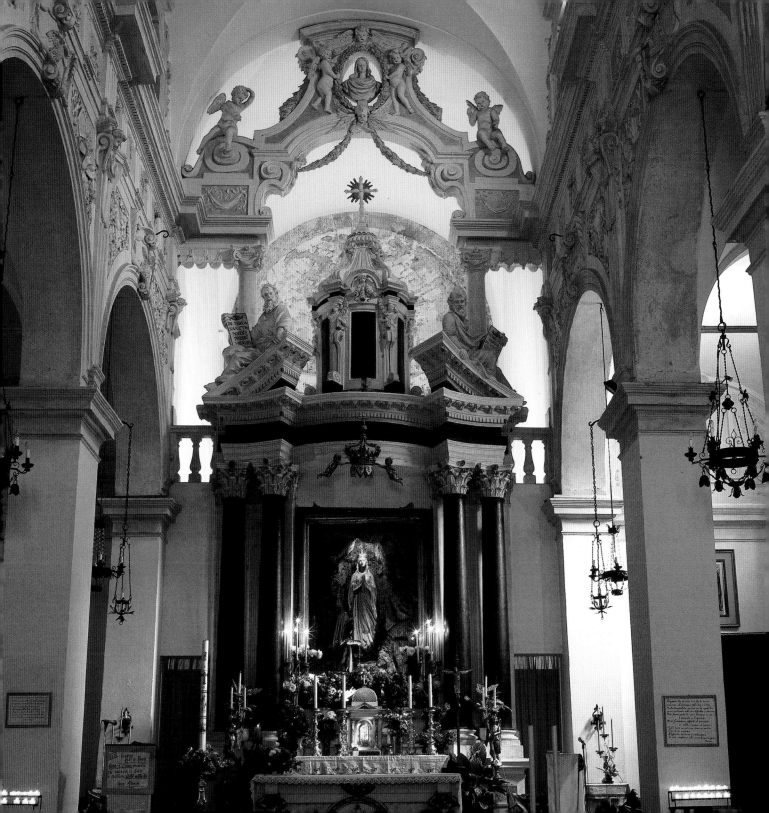

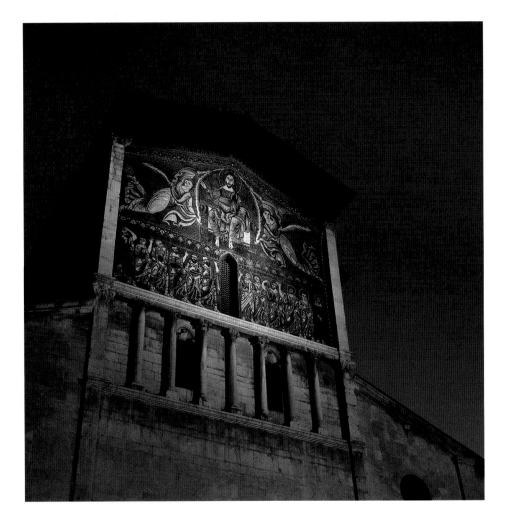

ABOVE: The church of San Frediano, built in the early 1100s, stands at the northern end of Lucca's Via Fillungo district. The church is distinguishable from other Romanesque churches in the city thanks to a golden mosaic at the peak of the facade depicting Christ and the Apostles in elegant flowing style. The mosaic tiles sparkle in the early-evening light.

OPPOSITE: Exploring the palatial interior of San Frediano—which houses several chapels—I came upon this detail of the magnificent Romanesque sculpted baptismal font depicting the story of Moses in marble quarried from nearby Carrara. Following our visit to the cathedral, we had lunch at Buca di San Antonio, savoring their wonderful homemade ravioli with black truffles and a bottle of Vermentino from Guado al Tasso.

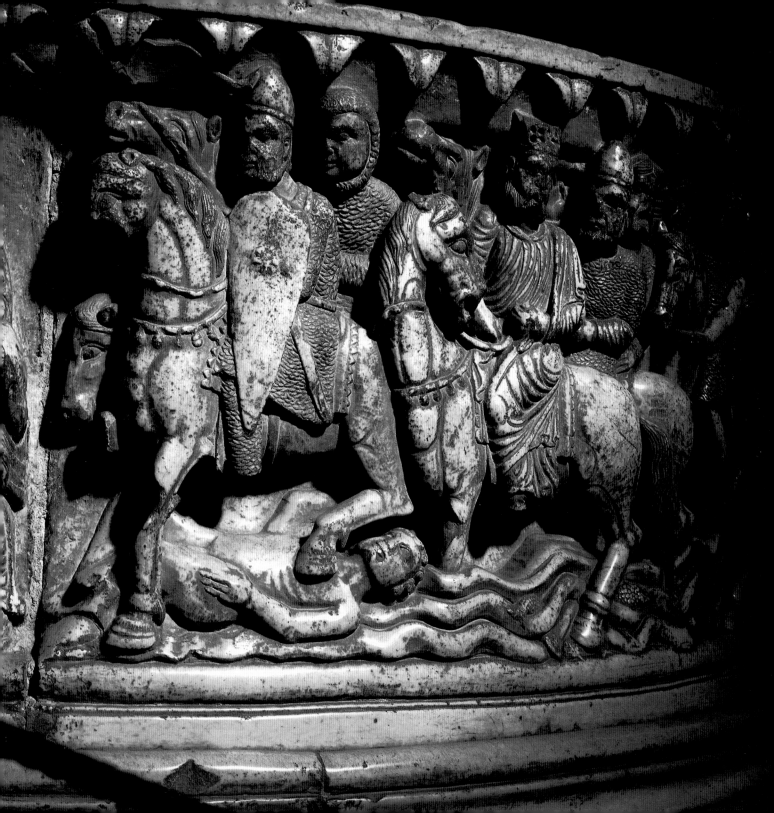

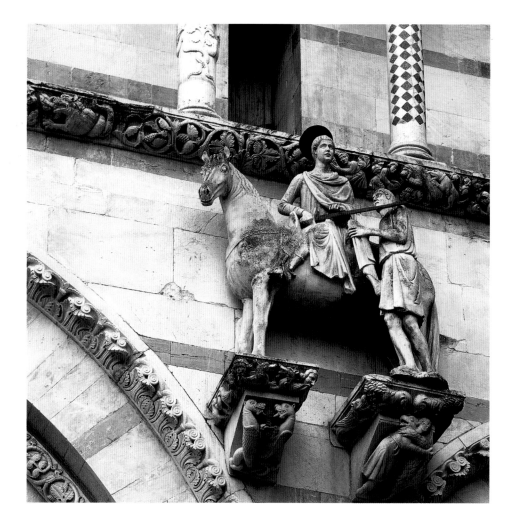

A detail from the beautifully preserved facade of Duomo di San Martino in Lucca. Of the structure originally begun in 1063 by Bishop Anselm, only the great apse with its tall columnar arcades and the fine campanile remain.

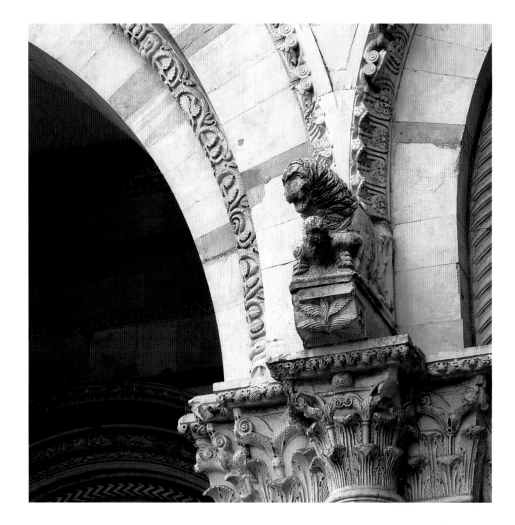

Another fanciful detail from the Duomo di San Martino exemplifies the intricacy of the facade. The interior of the duomo is well worth exploring, as it houses the most precious relic in Lucca, the *Volto Santo* (Sacred Countenance). This cedar-wood crucifix and image of Christ, according to the legend was carved by his contemporary Nicodemus, and miraculously conveyed to Lucca in 782.

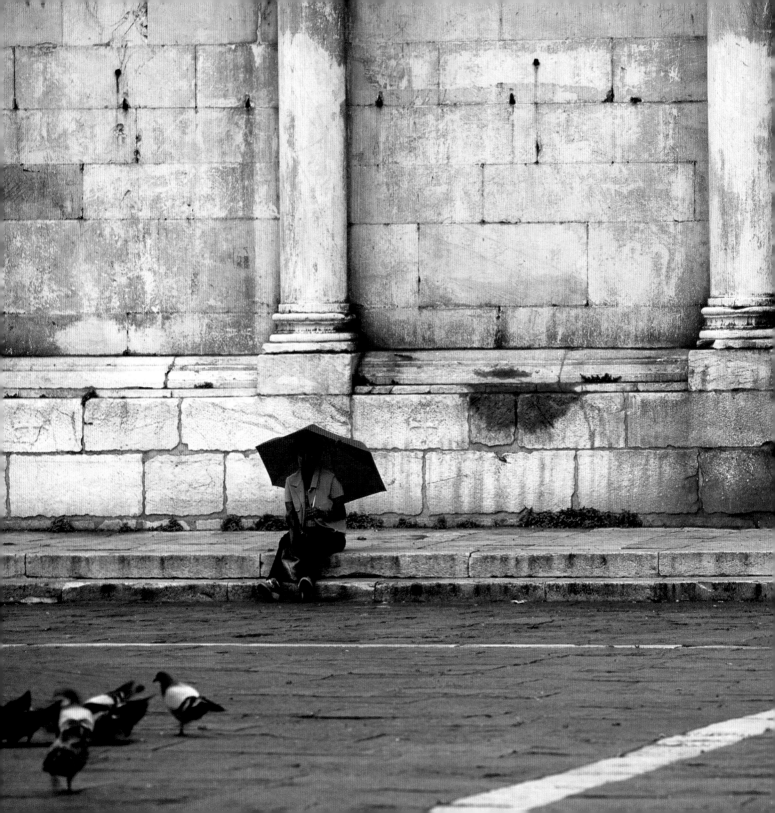

I taly, and the spring and first love all together should suffice to make the gloomiest person happy.

BERTRAND RUSSELL

While we were walking across the Piazza San Michele, it began to rain very suddenly. Everyone ran for cover—except this woman with her bright orange umbrella.

OPPOSITE: The walls that surround Lucca, most of which were built in the sixteenth and seventeenth centuries to protect the city from invaders, now help reduce the heavy traffic that plagues most Italian cities. Many of the main roads and by-ways are restricted to pedestrians, and bicycles have largely replaced cars, making the town truly walkable. As I strolled the Via Battistero toward the Duomo di San Martino, a typical medieval street scene appeared before me, with the exception of the ubiquitous blue bicycle.

ABOVE: Marsha loves to explore hardware stores. This tiny shop in Lucca caught her eye with its artfully displayed brass castings and wind vanes. Fortunately, only the small decorative cast-brass picture hooks found their home in an empty corner of her purse.

OPPOSITE: These colorful fruit sweets were on display at Lucca's Caffe di Simo, a patisserie with the charm and ambience of another time. In fact, it used to be the haunt of the native Puccini, who was born on Via di Poggio just across the street from the San Michele in Foro. There he began his musical career as a choirboy.

ABOVE: Caffe di Simo soon became our favorite spot for a midmorning cappuccino and pastry.

Love and understand the Italians, for

the people are more marvellous than the land.

E.M. FORSTER

The Piazza Napoleone is a shady square just south of Piazza San Michele. In the evening it becomes the center of Lucca's *passeggiata*—the Italian tradition of a slow, gentle stroll through the main streets of the old town. The piazza also comes alive at night with lively restaurants and music from this colorful carousel. Have a glass of wine or a cappuccino at one of the trattorias on the piazza.

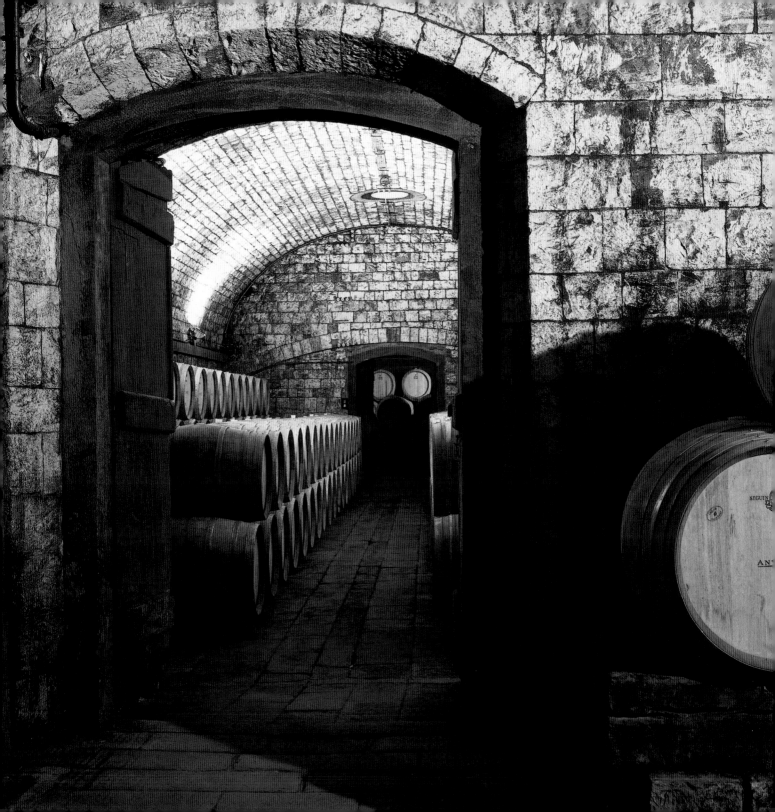

II

CHIANTI WINE COUNTRY

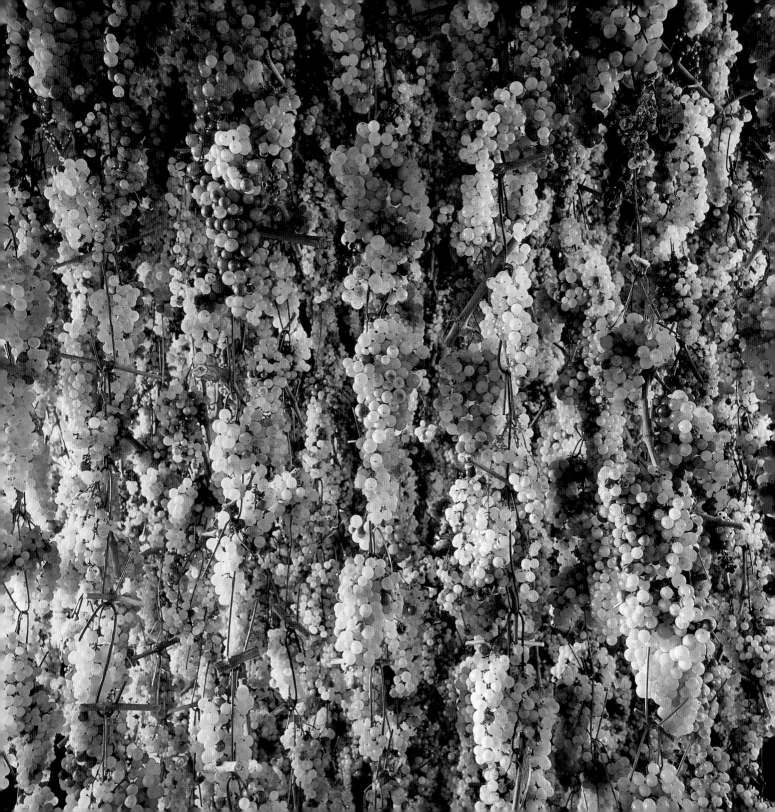

Let us get up early to the vineyards;

Let us see if the vine flourish, whether

the tinder grape appear.

SONG OF SOLOMON 7:12

PRECEDING SPREAD: Badia a Passignano, the eastern outpost of one of Chianti's most powerful religious institutions, was built in the 900s. The Antinori family owns the vineyards surrounding the abbey. The wine cellar shown here—located directly beneath the monastery—houses the many fine Antinori wines, including the Chianti Classico Riserva di Badia a Passignano. We tried their Reserva DOCG 2001 and compared it favorably with Napa Valley's finest.

OPPOSITE: Grapes drying for the Vin Santo at Casalare in Castellina.

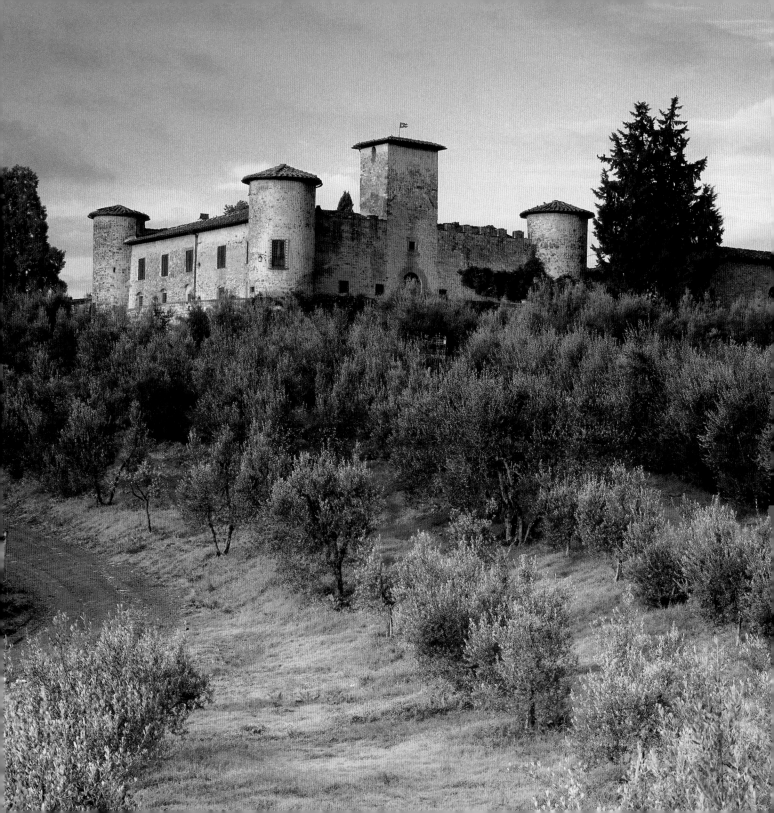

The clusters of grapes were enormous and dense, peeking out from under fading leaves. I groped around for the stem of one near me, found it, and pulled. Nothing happened. I pulled again. The vine shook. Then I noticed Nonna standing beside me, holding out a pair of pruning shears, smiling kindly and saying, "*Sono più forte di noi.*" They're stronger than us. It was only then that I heard the subtle clicking of everyone's pruning sheers as they clipped the thick, woody stems of the grapes.

FERENC MÁTÉ

Looking out our window of the Agriturismo of Castello di Gabbiano at sunrise, I was greeted by this enchanting view. Castello di Gabbiano sits among vineyards atop its hilly estate. As guests of the Agriturismo we got to see grapes being harvested and made into wine at summer's end, and in fall watched olives being picked and pressed into oil. Small casks of balsamic vinegar are also aged in an ancient stone building adjoining the guest accommodations. We enjoyed "tasting" all of these over dinner with our hosts Ivano and Cornelia Riali at Il Cavaliere on the premises.

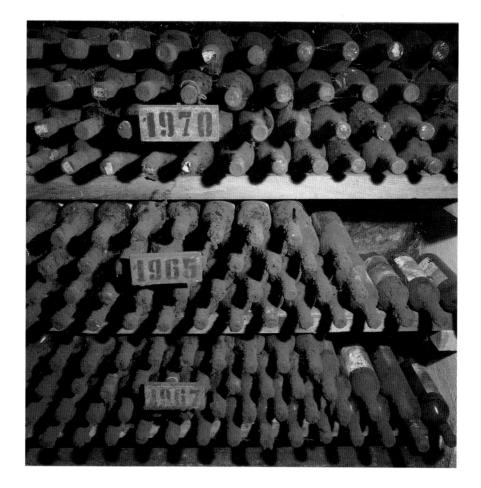

OPPOSITE: It was approaching Halloween when we arrived in Castelnuovo Berardenga. I was pleasantly surprised to see the exterior of this home festively decorated for the season. In a quiet corner of the Chianti region, this is a charming hilltop village not overcrowded with tourists.

ABOVE: Aging bottles stored in the cellar beneath the ancient Badia a Coltibuono—the abbey of the good harvest. The abbey is believed to have been founded in 770, passing in ownership to the Vallombrosan Order in the twelfth century. It is rumored that to qualify for membership in the order, one had to be capable of consuming five bottles of wine every day. More recently, the estate has been owned for the past 150 years by the Stucci-Prinetti family and today is managed by Emanuela Stucci-Prinetti, the first female to preside over the Marchio Storico del Chianti Classico. The cellar ages one of the finest Chianti Classico wines to be found in Tuscany.

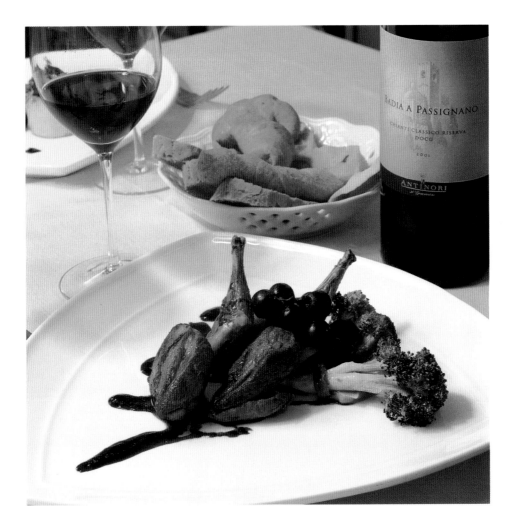

Chef Matia Barciulli has run the kitchen and bakery at the Osteria di Passignano for the past five years, baking six different types of bread daily, and teaching cooking classes for both Italians and foreign tourists. Matia's oven-roasted pigeon breast in grape sauce with crunchy thigh and broccoli bouquet is delicious.

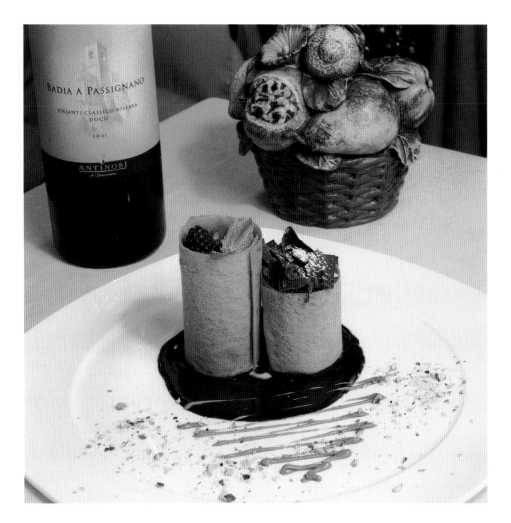

Matia's wafer cannoli filled with chestnut mousse and gianduia chocolate foam with hot chocolate sauce is as decadent as it is beautiful.

ABOVE: La Castellana Ristorante in Montefioralle is our favorite trattoria in Tuscany. Perched on the hillside above Greve, it has a great view of the countryside and a singing waiter—if encouraged! Be sure to try the prosciutto and melon.

OPPOSITE: Fattoria Corzano e Patterno is a farm situated near San Casciano in Val di Pesa, a town south of Florence that is the largest and busiest in the Chianti region. The farm is dedicated to the production of fine wine, olive oil, and excellent sheep cheeses. Our host Antonia introduced us to one of the most sought-after Pecorino cheeses in all of Tuscany, which she makes by hand using the milk from the Sardinian sheep grazing on the estate. We enjoyed four different ages of Pecorino over lunch in her villa, which dates back to 900.

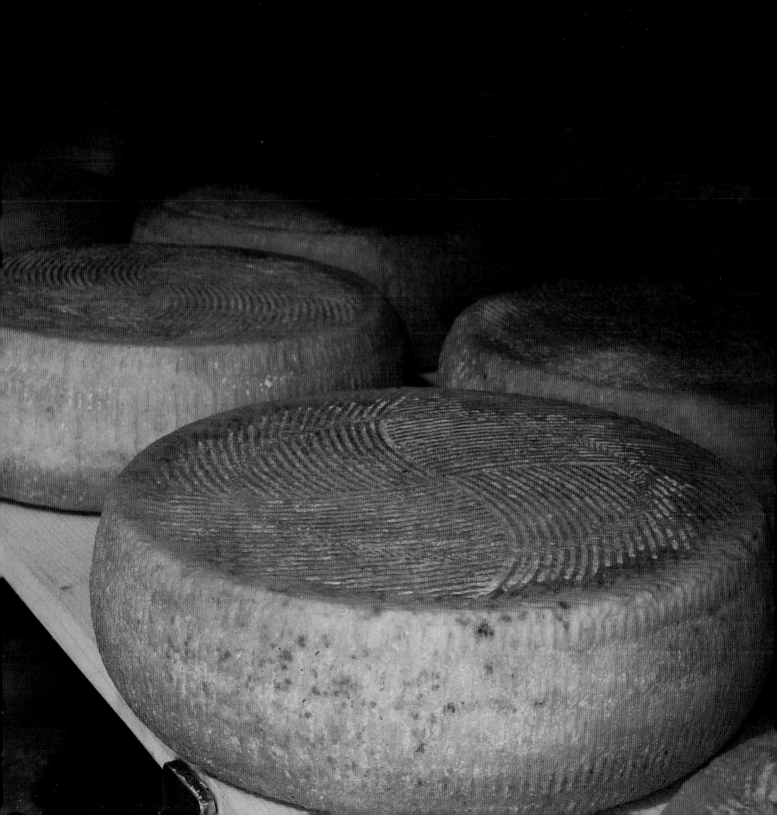

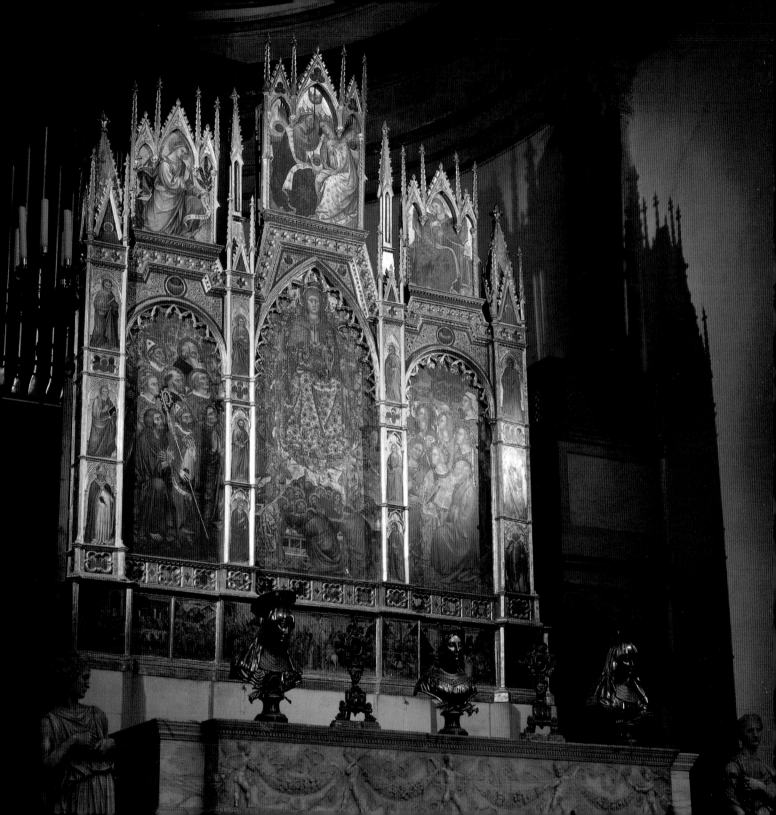

The churches were the best. God was in the very plaster smeared across the walls in readiness for frescoes: stories of the gospels made flesh for anyone with eyes to see.

SARAH DUNANT

The interior of the Duomo in Montepulciano houses this alter containing a *Madonna with Child* by an unknown Florentine artist of the fourteenth century.

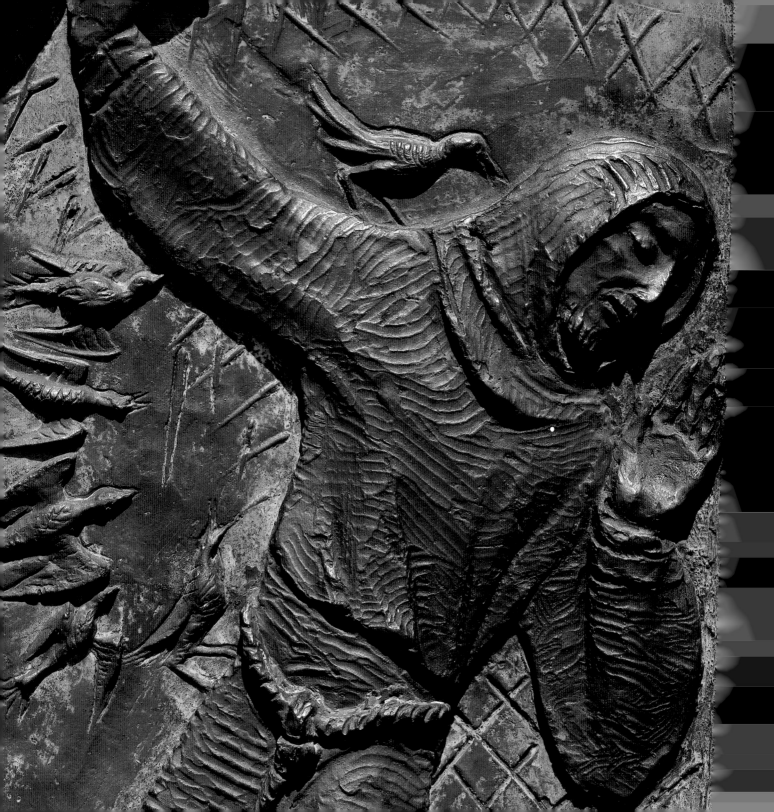

OPPOSITE: The massive bronze door entering the parish church Santa Maria di Assunta in Panzano was sculpted by Umberto Bartoli and depicts Saint Francis of Assisi with his animals. From the church, we walked down the hill and found the weekly market in full swing. On offer was a surprising variety of food, from fresh fish to black chard—a necessary ingredient in the quintessential *ribollita*.

ABOVE: The town of Panzano was originally a medieval castle, and still preserves some of its old walls and towers. The one main street in the village leads right to Santa Maria di Assunta, which was completely renovated and restored a century ago. The beautiful stonework on display here frames the *Assumption* for which the church was named. A wonderful restaurant and bar at the foot of the steps leading to the church boasts a view over olive orchards and vineyards.

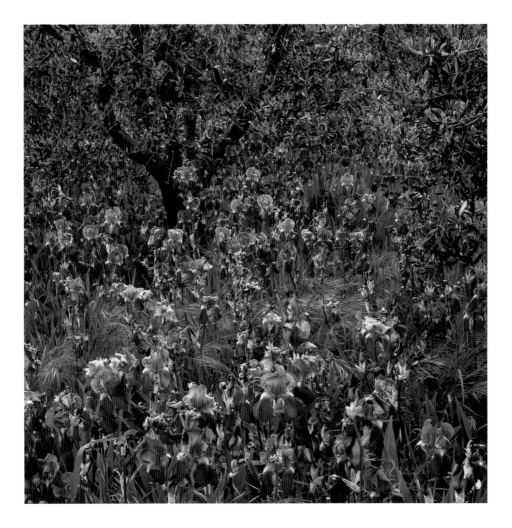

ABOVE: Winding up the hillside from Greve, we came across an olive orchard outside Casole with wild irises in full bloom. In early-summer months the countryside surrounding the medieval village is rich with wildflowers. It isn't surprising to come across orchids by the side of the road, and poppies mixed in with the maturing corn crops and olive trees.

OPPOSITE: A lovely view of the Badia a Coltibuono grounds. Set among pines, oaks, chestnuts, and vines, the beautifully manicured gardens are breathtaking. Gourmet cooking classes taught in the adjoining *abbadia* provide mouthwatering aromas as you stroll through the gardens.

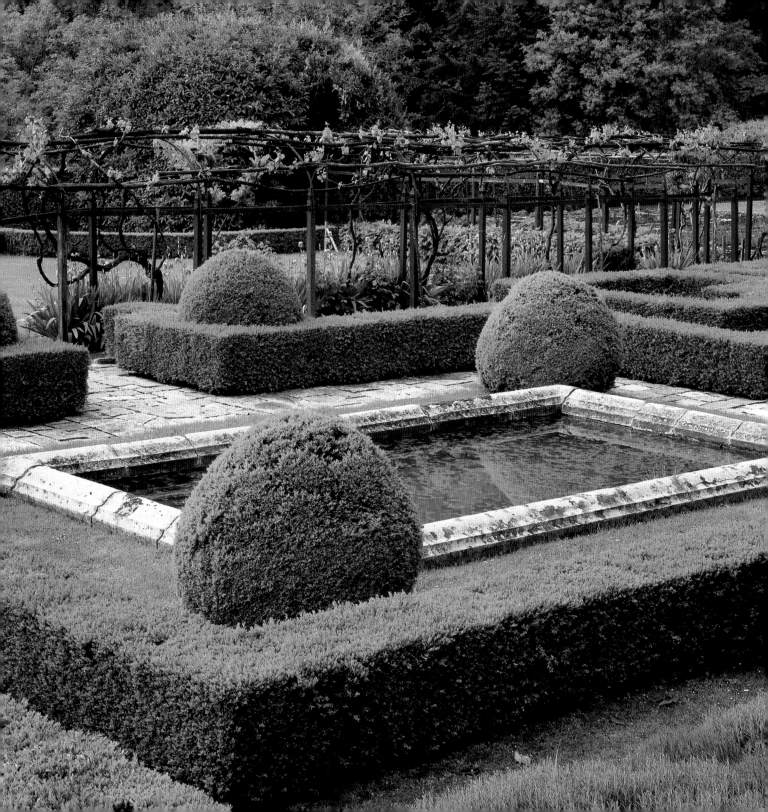

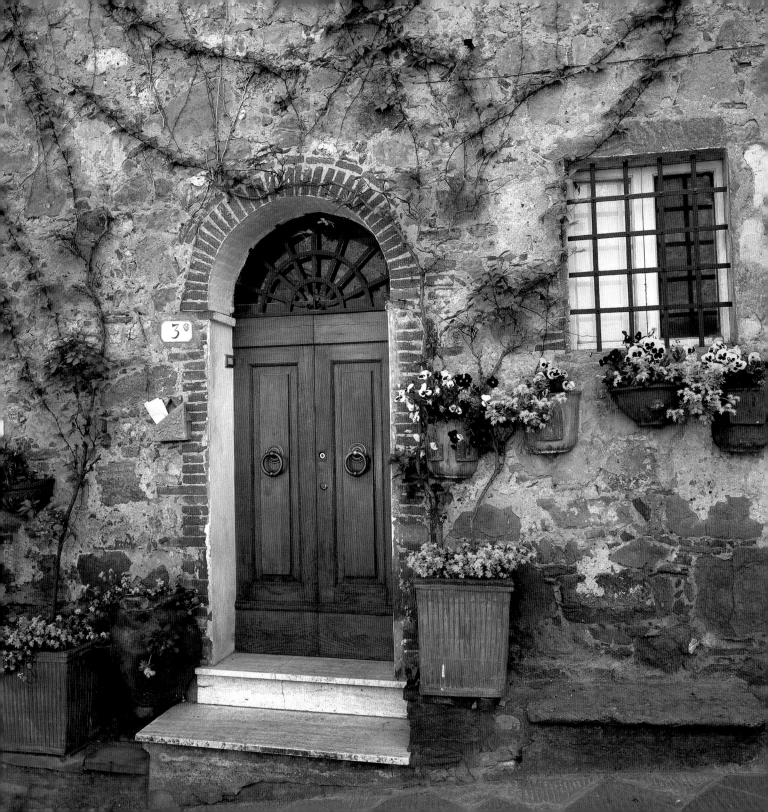

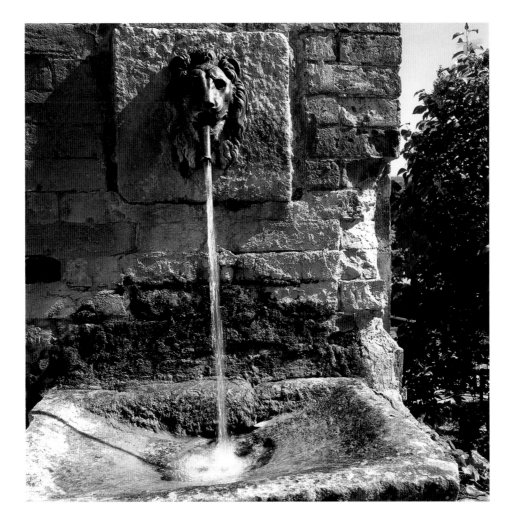

OPPOSITE: A wonderful example of the classic Tuscan arched doorway, surrounded by house vines and flowers. Leaving Petroio, we headed for lunch to Castelmuzio, where we discovered one of our favorite restaurants in Tuscany: the Il Camarlengo. As an appetizer we were introduced to Colonnata, an aged-spiced pig fat on crostini, which, although pure fat, was delicious!

ABOVE: The village of Petroio is hidden in the hills along an old pilgrim route in a rocky, wooded setting. Just north of town is a small factory manufacturing the terra-cotta for which Petroio is well known, and which adorns the city walls. This fountain had sprung a leak, causing quite an excitement in the village that morning. I had to take this shot through the crowd of older village men who were watching the workers find the leak.

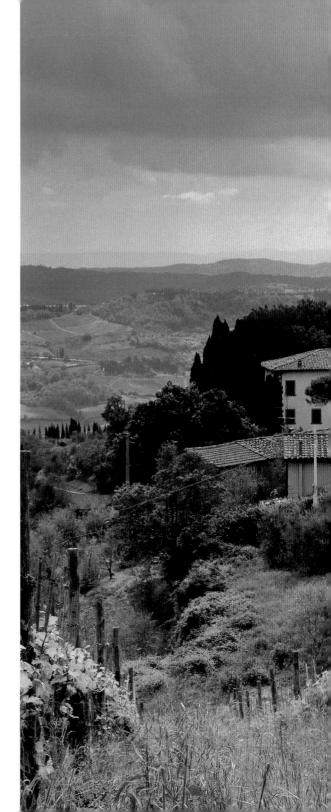

Red sun setting
over Toscana
through the cypresses
over the red tile roofs
and green lush vineyards
near Volterra and Piccioli
Paesani on old bikes
on straight dirt roads
and the trees turning brown
like a drought
as the sun goes out
and the streetlights
coming on
in little Ponsaco
its iron churchbell clanging—
Night falls!

LAWRENCE FERLINGHETTI

Approaching Volpaia from above, we had a wonderful view of one of the most picturesque villages in Chianti. Surrounded by a patchwork of vineyards and the ubiquitous cypress trees, this medieval hamlet features an ancient ruined castle and a Brunelleschi-style church, La Commenda. Though small, the town also boasts several very good trattorias and a winery hidden inside the old castle.

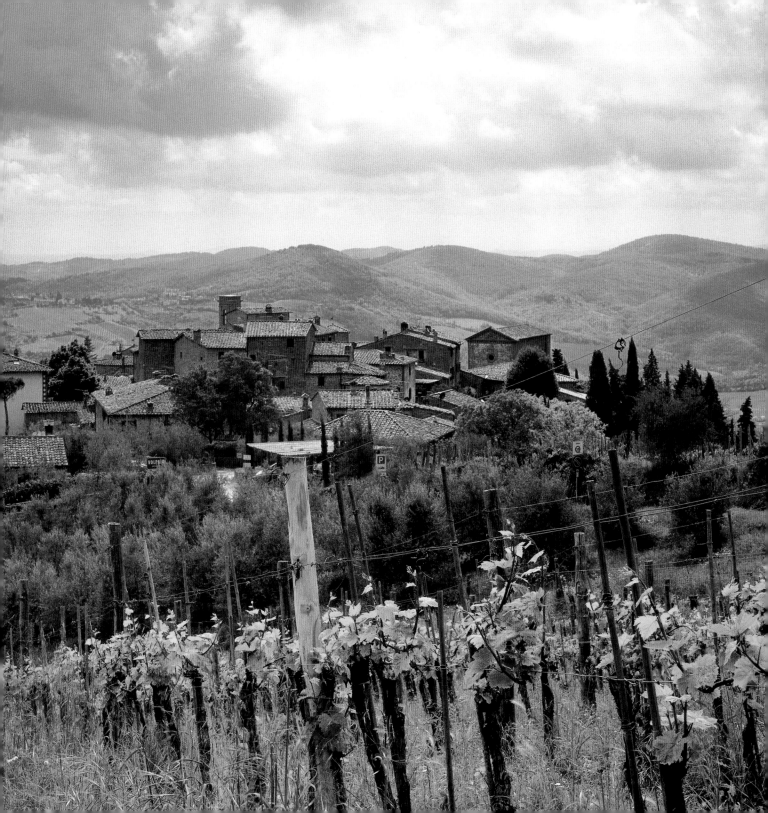

Close your eyes and pronounce the word Tuscany.
It summons up associations of earthly perfection, of
images sprinkled with happiness, daubed with ocher
and marble (white from Carrara, green from Prato, pink
from Maremma), and a cyprus-lined path that leads
nowhere, an infinity of hills bathed in clear light blessed
by the gods, a honey-colored villa glimpsed from a
baroque garden, the perfume of olive oil, faded frescos
in silent cloisters—and a long procession of great men:
Leonardo da Vinci, Machiavelli, Galileo, Michelangelo,
Lorenzo de' Medici, Giotto, Petrarch, Dante, Pinocchio.

SONJA BULLATY AND ANGELO LOMEO

This elegant one-kilometer road lined with cypress trees planted centuries ago leads to Tenuta di Arceno, near Castelnuovo Berardenga. The estate's history stretches back to the eighth century, when wine was first introduced to the Tuscan region. Today the original estate plantings grow alongside rows sown during the 1990s. The entire estate is owned and managed by Jess Jackson, a California vintner.

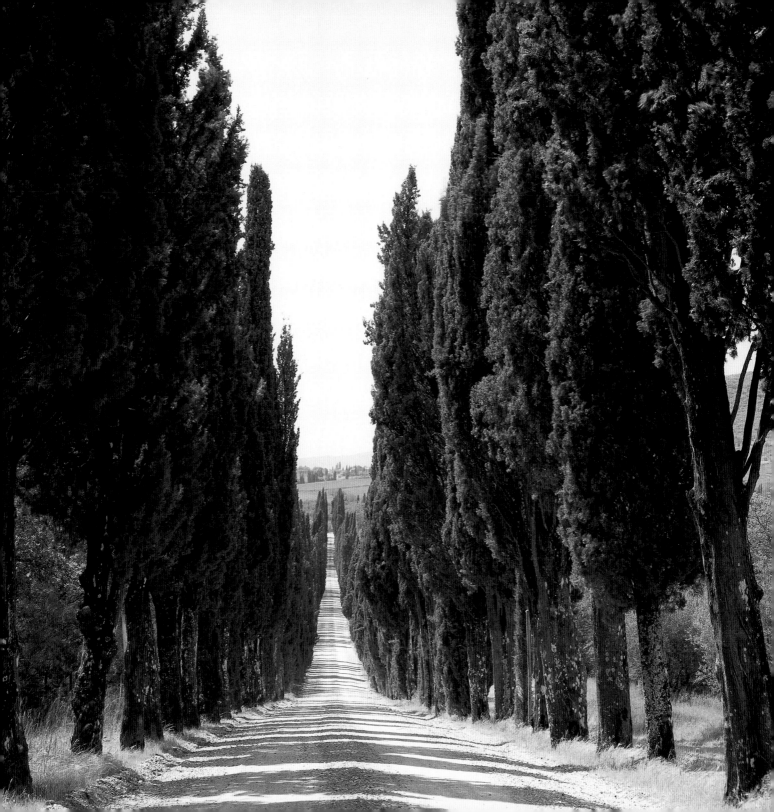

III

EASTERN GOLD

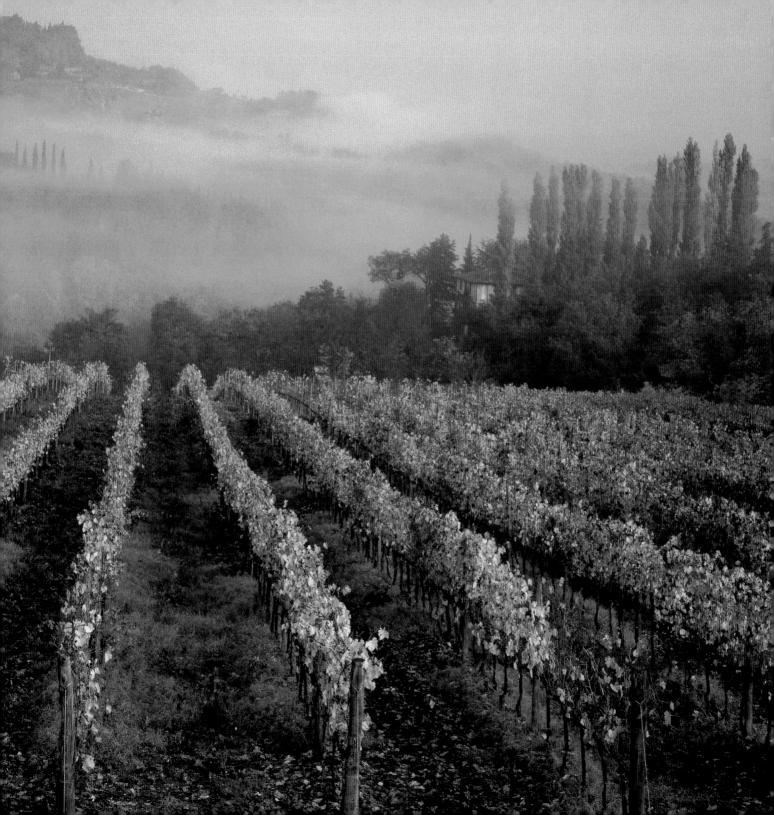

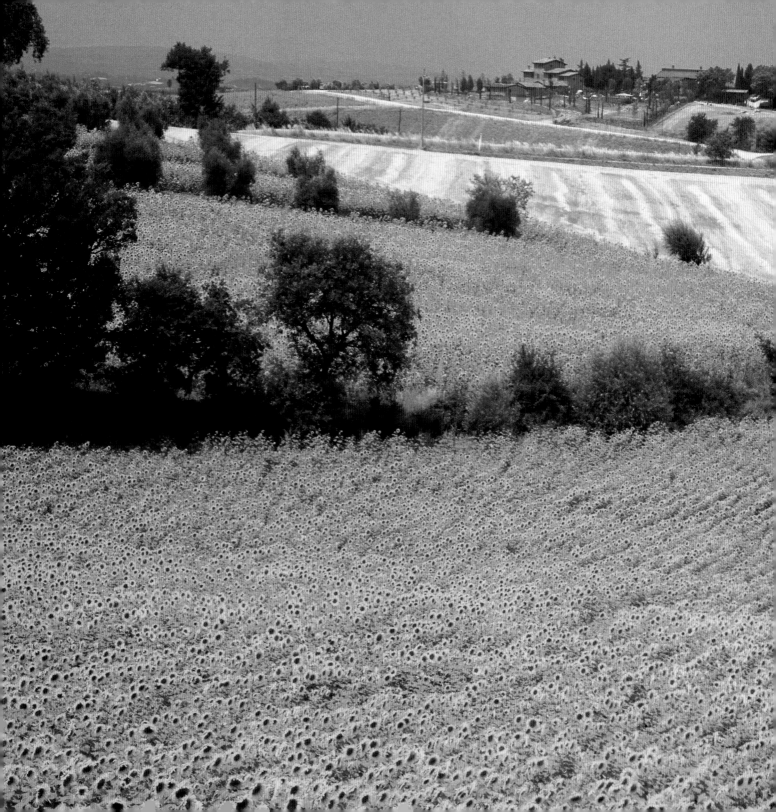

Guidebooks describe Cortona as "somber" and "austere." They misjudge. The hilltop position, the walls and upright, massive stone buildings give a distinctly vertical feel to the architecture. Walking across the piazza, I feel the abrupt, angular shadows fall with Euclidean purity. I want to stand up straight—the upright posture of the buildings seems to carry over to the inhabitants. They walk slowly, with very fine, I want to say, *carriage*. I keep saying, "Isn't she beautiful?" "Isn't he gorgeous?" "Look at *that* face—pure Raphael." By late afternoon, we're sitting again with our espressi, this time facing the other piazza. A woman of about sixty with her daughter and the teenage granddaughter pass by us, strolling, their arms linked, sun on their vibrant faces. We don't know why light has such a luminous quality. Perhaps the sunflower crops radiate gold from the surrounding fields. The three women look peaceful, proud, impressively pleased. There should be a gold coin with their faces on it.

FRANCES MAYES

PRECEDING SPREAD: We left Castello di Gabbiano in the morning fog heading toward Rada. Approaching Castellina, the fog parted, and this autumn vineyard turning shades of gold, ocher, and vermillion came into view.

OPPOSITE: Traveling toward Cortona from the Abbadia di Farneta, the countryside becomes very pastoral with its rolling hills among the small villages and farms. In midsummer it is on fire with sunflowers interspersed with fields of wheat and corn, creating a patchwork of colors and shapes.

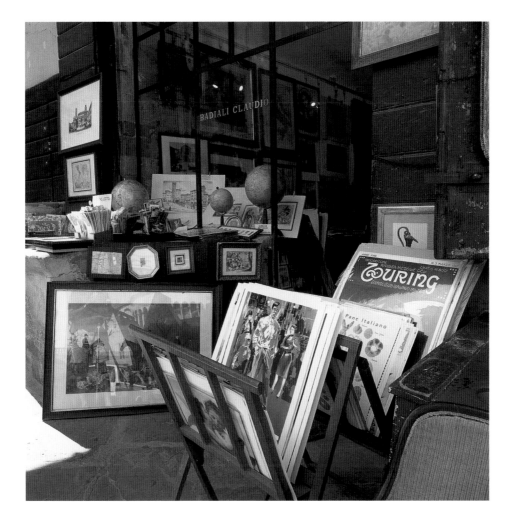

OPPOSITE: This sight reminded me of the classic Italian film *Cinema Paridiso*, and it certainly fit into the village of Ambra, which is quintessential Tuscany—small, quiet, charming, with quaint surprises at every turn.

ABOVE: Antiques fill the shops around the main Piazza Grande in Arezzo. Furniture making, marketing antiques, and jewelry making are the ancient city's current industries. This shop sold antique prints from century-old books and other treasures. Marsha couldn't resist a number of lovely hand-tinted bird prints to burden our already overstuffed suitcase.

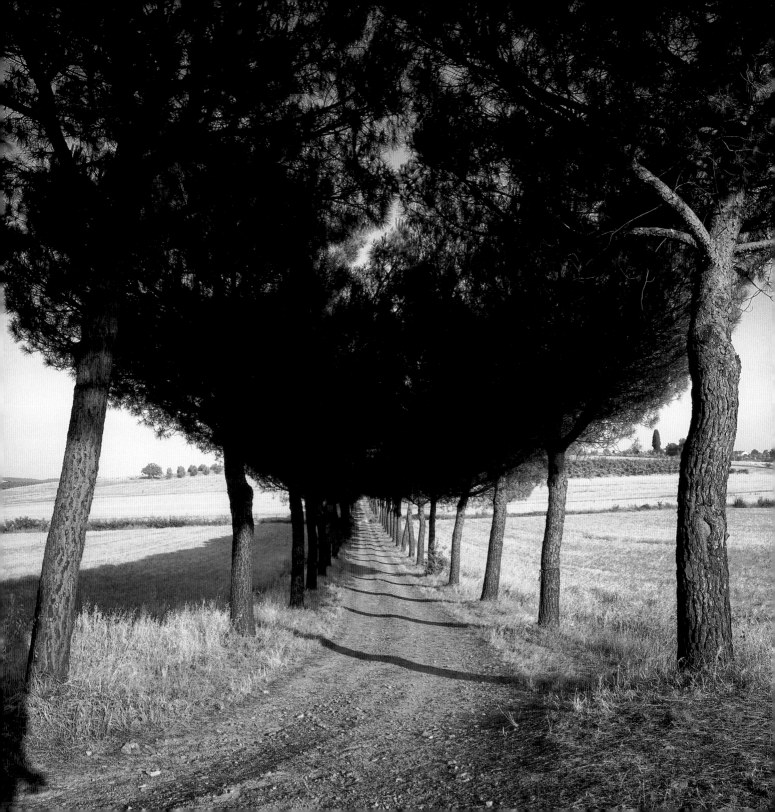

The open country is one of Tuscany's great charms. Rare are fences that delineate what one owns—a very few exist to hold in sheep or horses—so, for the lovers of long walks, the country is paradise. And the small dirt tracks that wind and swoop, so intimate and untravelled, stir in you the sense that something wonderful and unforeseen may lie around the bend.

FERENC MÁTÉ

These trees lining a small road in Manzano, near Cortona, are not the typical Tuscan cypresses but the particularly beautiful umbrella pine. This evening we dined at Poggio al Sole outside Pergo and had a dinner spectacular enough to rival Napa Valley's famed "French Laundry" restaurant.

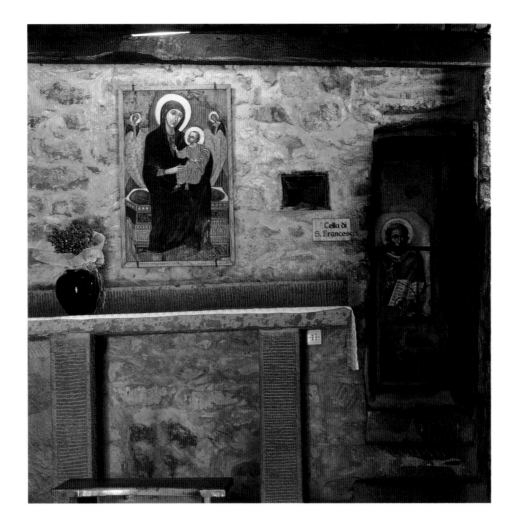

ABOVE: In a remote and wild area near Cortona, Saint Francis of Assisi founded a small monastery called Le Celle in 1211. The monastery was constructed on the side of a cliff with a waterfall cascading down the rock wall toward the Val d'Chiana. Walking through the grounds, we came to a small rock building and found the cell that was Saint Francis's home for several years. The monastery has been a work in progress over the centuries and today continues to house a small monastic order in a beautiful natural setting.

OPPOSITE: The Palazzo Comunale stands in the Piazza della Republica, the heart of Cortona. Here we watched a young couple, just married, run down the stairs under a shower of rice thrown by their wedding party. Later that same evening the piazza was the scene of great celebration following Italy's World Cup victory, which we watched from a nearby gelato shop. By the time this photo was taken, the only sound was the street sweeper.

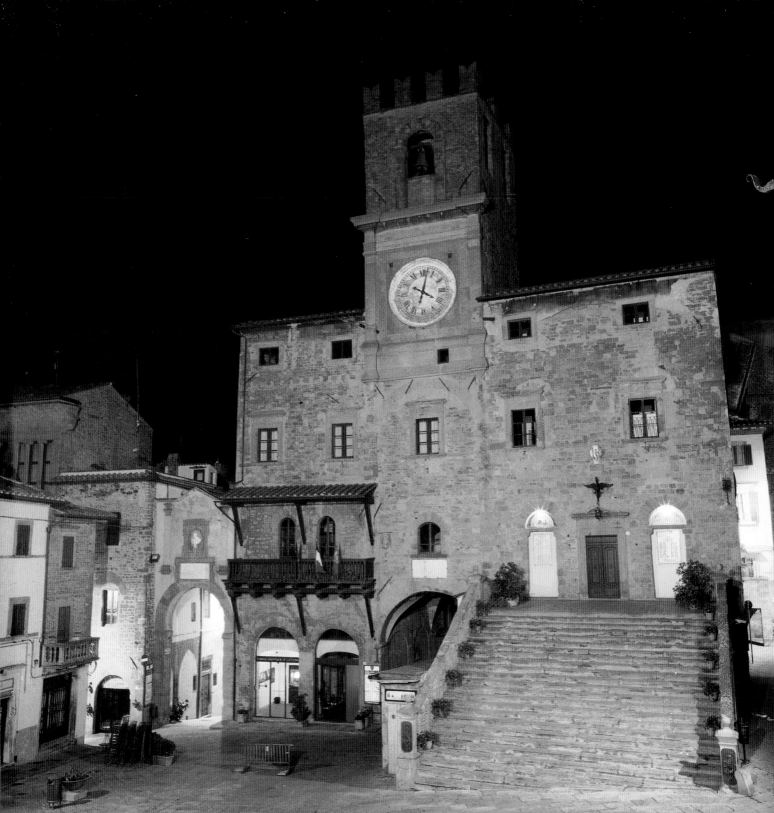

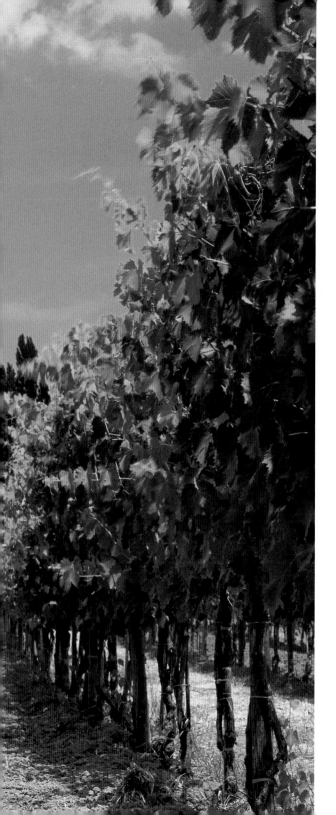

The geography of wine is as much an emotional landscape as it is a physical terrain.

ANTHONY DIAS BLUE

These vineyards are near Montepulciano. The grapes from these vines provide the juice for the world-famous Vino Nobile di Montepulciano, which we tasted over lunch in the medieval hilltop town.

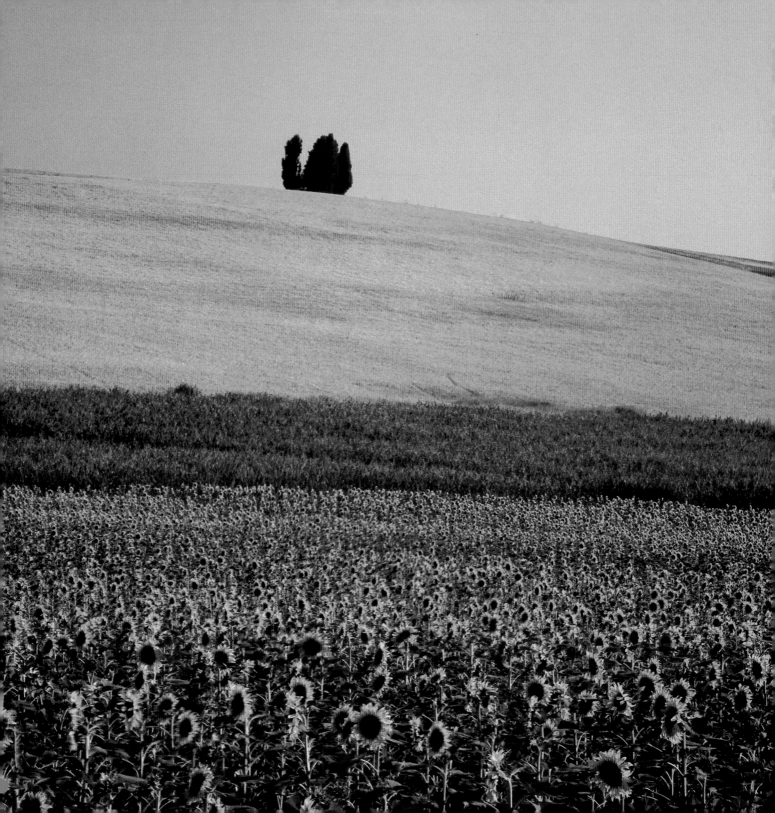

Italy is a dream that keeps returning for the rest of your life.

ANNA AKHMATOVA

As we returned through rolling countryside of the Val di'Chiana to the Agriturismo Poggio al Sole near Pergo at dusk, the soft warm light illuminated a field of sunflowers, corn, and wheat with one lone cypress tree on the horizon. Although we were overdue for another great pasta dinner with our hostess Beta, it was worth the stop.

There is a great deal of usually good-natured rivalry between Tuscans and Umbrians, especially when it comes to the question of food. The Tuscans chide the Umbrians for being too hedonistic, drinking too much wine and not taking life seriously enough, and they distrust the richer Umbrian cooking. The Umbrians, on the other hand, maintain that the Tuscans have no sense of humour, are too severe and prone to keeping their money well tucked away under the mattress; they deride the plainness of Tuscan cooking. Where a Tuscan uses just toasted bread, olive oil, salt and garlic to make the delicious *bruschetta*, an Umbrian will add a few slices of truffle to his if at all possible.

ELIZABETH ROMER

Castello della Sala is considered one of the finest medieval castles in Italy, just over the Tuscan border in Umbria. The small Renaissance chapel near the castle gates was built in the fifteenth century as a mark of gratitude for the peace established between two families who had been feuding for rule over the region. Inside the small chapel is this large fresco of the Magi in Bethlehem painted by order of Giovanna Monaldeschi della Cervara. The estate is now owned by the Antinori family and produces a fine dessert wine, Muffoto della Sala, made from botrytized grapes picked in early November to allow the morning mist to develop the "noble rot" with its unmistakable flavor.

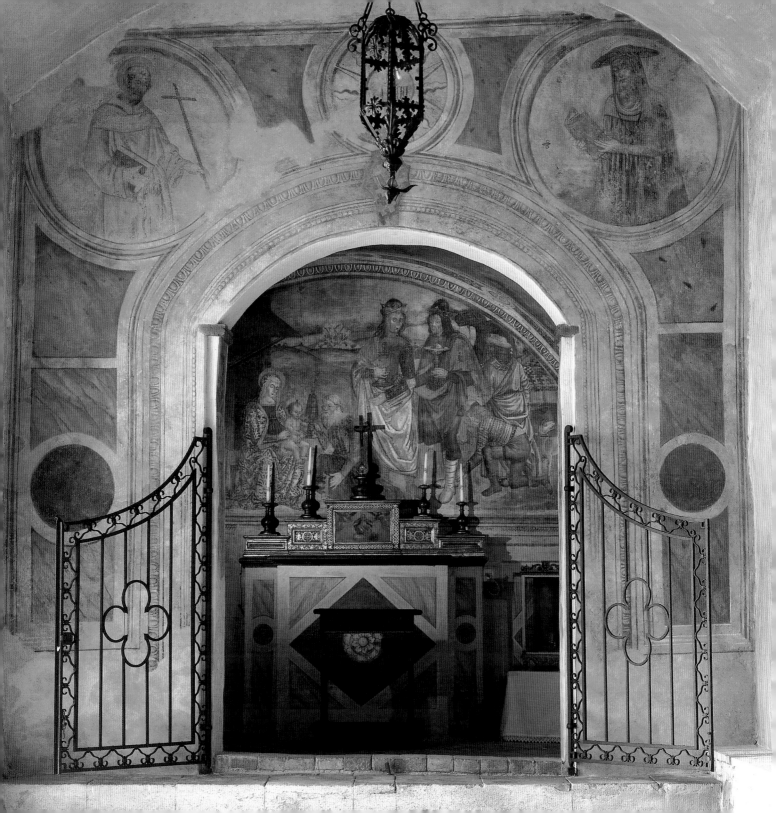

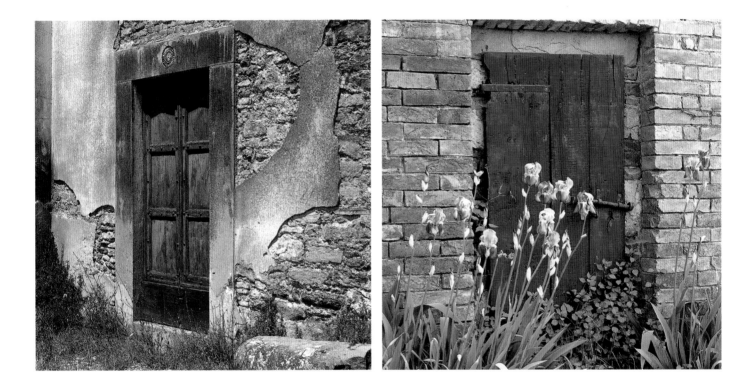

ABOVE, LEFT: On the hillside below Cortona, a small private chapel adjoins an old stone villa. The chapel's green door caught my eye, exemplifying the bright—albeit weathered—colors used to enhance Tuscan homes.

ABOVE, RIGHT: The vineyards to the east of Montalcino toward Tornieri grow the classic grape varietal Sangiovese, the foundation for the great Brunello wines of Montalcino. Ancient stone sharecroppers' houses dot the countryside, with patches of lavender irises in every yard.

ABOVE, LEFT: A beautiful antique bed frame outside one of the many antiques shops that surround the Piazza Grande in Arezzo. On the first Sunday of every month Arezzo hosts an antiques fair in the piazza—one of the oldest antiques traditions in Tuscany. The wares are pricy, but it is still possible to make some rare discoveries.

ABOVE, RIGHT: A rustic polychrome door in the heart of Montebenichi, a tiny village northeast of Siena. Just up the hill is the renowned Castelletto di Montebenichi, one of the finest hotels in Tuscany and a virtual museum of Etruscan art dating to the ninth century.

OPPOSITE: Traveling the road from Ambra through a valley filled with sunflowers, we wound our way up the hillside toward the tiny village of Montebenichi through vineyards, ancient olive orchards, and cypress trees. We came across this small *pieve*—private church—as the sun was about to set.

ABOVE: In October and November the olive harvest in Tuscany is in full swing. We stopped near Castelmuzio to watch the olives stripped from the century-old trees and fall into the nets spread underneath. The oil—pressed within hours of harvest—is a rich golden-green with an unforgettable herbaceous taste. We purchased several liters nearby and enjoyed the flavors at home over the ensuing months.

OVERLEAF: I came across this field of sunflowers a week or two before this photograph was taken, but the blooms had not fully opened. When I returned later in the early morning, sun flooded the field with light.

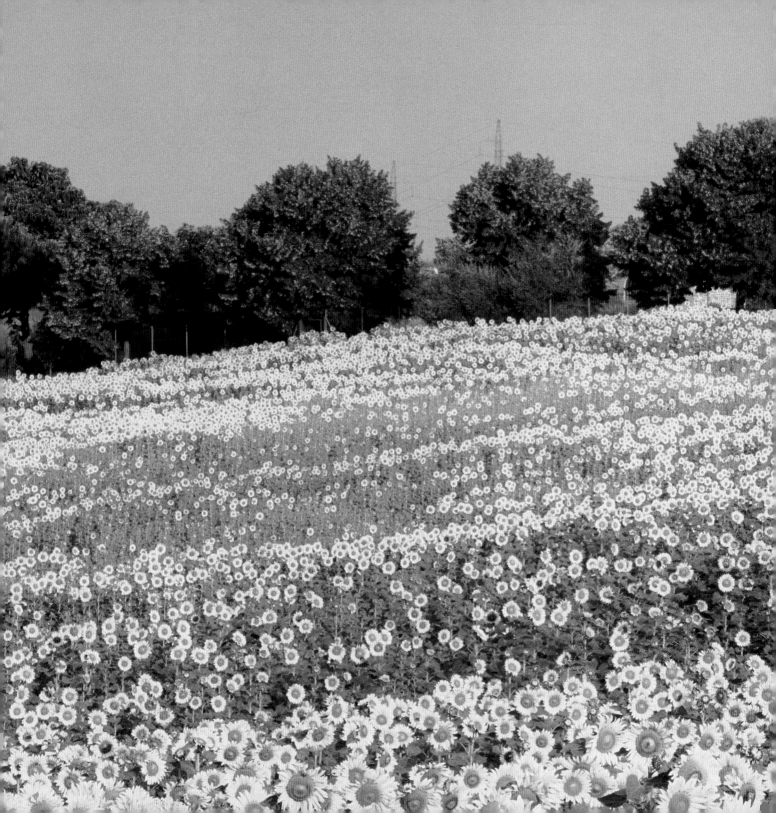

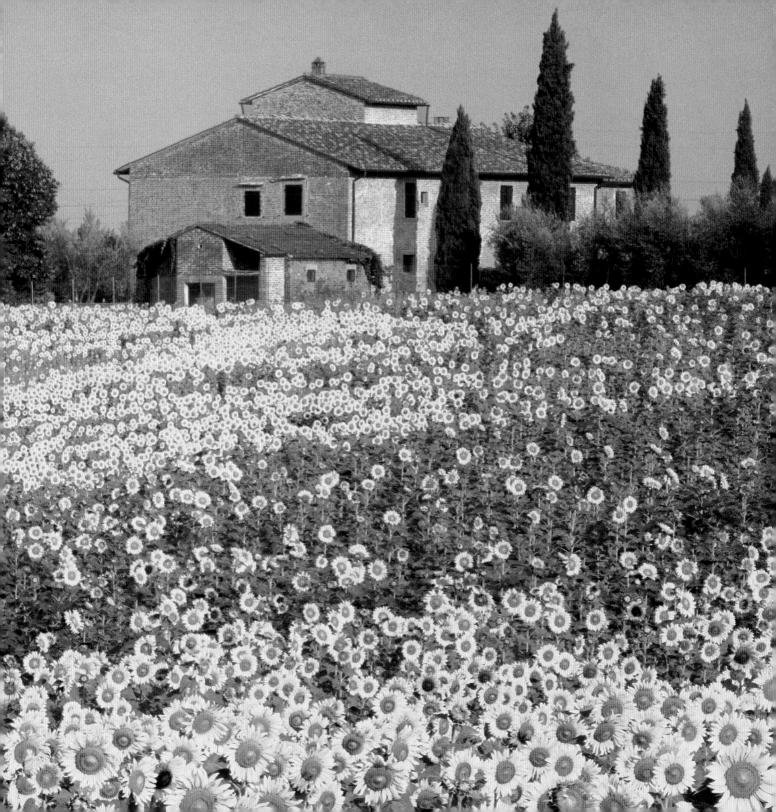

IV

SOUTHERN TUSCANY

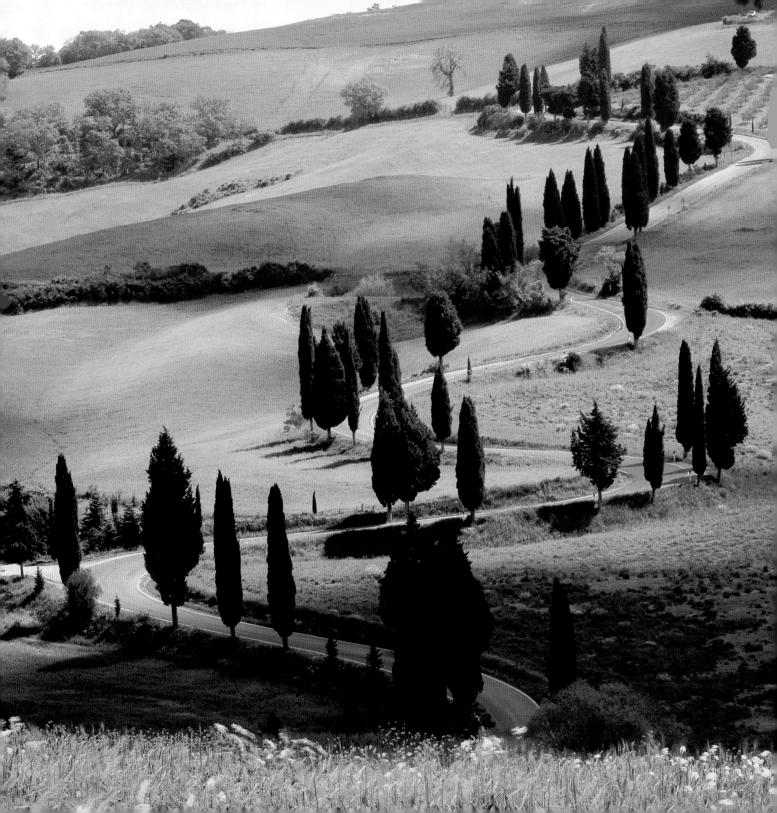

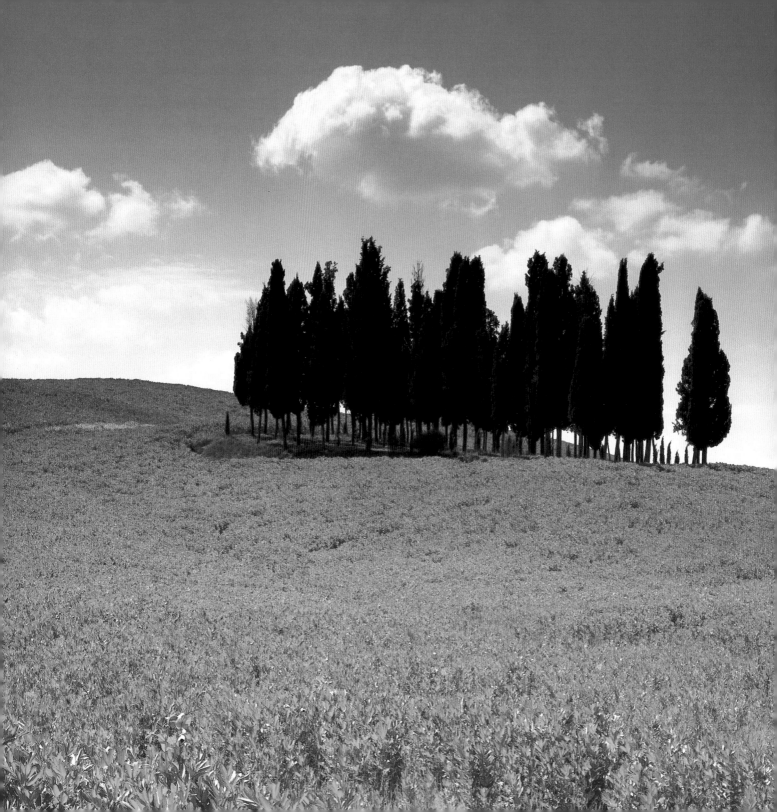

Did you ever see this place, I wonder? The coolness, the charm of the mountains, whose very heart you seem to hear beating in the rush of the little river, the green silence of the chestnut forest, and the seclusion which anyone may make for himself by keeping clear of the valley villages; all these things drew us. Robert and I go out and lose ourselves in the woods and mountains, and sit by the waterfalls on the starry and moonlight nights . . .

ELIZABETH BARRETT BROWNING

PRECEDING SPREAD: On a hilltop between Montepulciano and Pienza, Monticchiello is a small medieval village that was first documented in official paperwork in 973. La Porta, a restaurant near the entry gate, overlooks the Val D'Orcia, with Pienza in the distance. Marsha found a beautiful fabric shop here with fine linens owned by Fidia Cappelli, a few of which made their way into our already overstuffed suitcase. Visitors to the village in late July and most of August can enjoy the history of the town through Teatro Povero di Monticchiello, a theater entirely composed of local townspeople who write, act, and direct a production each year. Once the show is over, follow this road east toward Montepulciano through wheat fields in springtime green.

OPPOSITE: This often photographed cluster of cypress trees stands near San Quirico D'Orcia. Although now synonymous with the Tuscan countryside, the cypress originated in Persia or Syria and was brought to Italy by Etruscan tribes millennia ago. The Etruscans believed these trees to be supernatural, because they retain their leaves through winter while the other deciduous trees around them grow bare, and they can survive for two thousand years or longer.

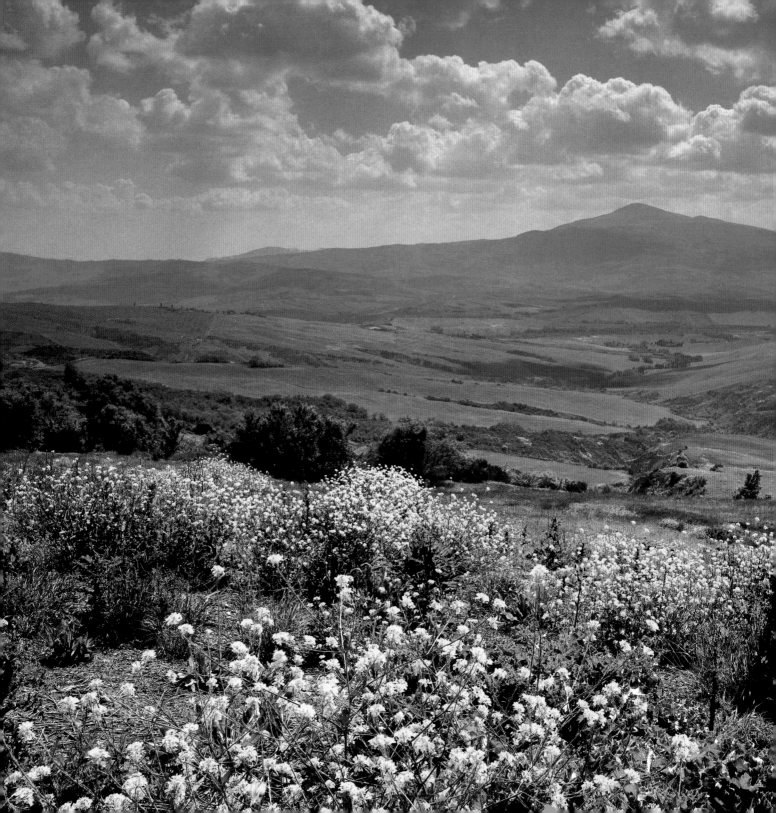

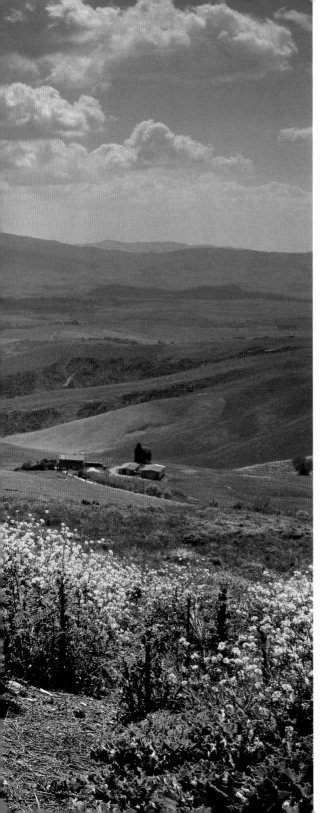

For the first time, in that year, I learned what every country child knows: what it is to live among people whose life is not regulated by artificial dates, but by the procession of the seasons: the early spring ploughing before sowing the Indian corn and clover; the lambs in March and April and then the making of the delicious sheep's-milk cheese, *pecorino*... Then came the hay-making in May, and in June the harvest and the threshing; the vintage in October, the autumn ploughing and sowing; and finally, to conclude the farmer's year, the gathering of the olives in December, and the making of the oil.

IRIS ORIGO

Near La Foce on a dirt road leading toward Monticchiello, fields of mustard spread across the hillsides of the Val D'Orcia beneath Mount Amiato. The valley is a World Heritage Site and perhaps the most scenic in all of Tuscany. We used the Agriturismo Terrapille near Pienza as a base to visit this area and enjoyed the warm hospitality of Giuliano, Elsa, Lucia, and Ilyas, who spent many hours leading us to the treasures of the surrounding countryside.

A man who has not been in Italy, is always conscious of an inferiority,

from his not having seen what it is expected a man should see.

SAMUEL JOHNSON

OPPOSITE: The majestic church of San Biagio—considered one of Antonio da Sangallo's Renaissance masterpieces and consecrated by the Medici pope in 1529—lies just outside the city gates of Montepulciano. My wife and I were fortunate enough to visit during a festive wedding celebration. The church is built in a Greek cross formation and features a large dome with a freestanding campanile. Made of blocks of travertine, a common limestone, it radiates a soft golden color that contrasts beautifully with the surrounding green pastoral fields.

OVERLEAF: In early May the wheat fields are mowed and left to rest briefly before the hay is rolled up and baled. East of Sorano the deep, well-drained volcanic soil is extremely fertile; crops are bountiful.

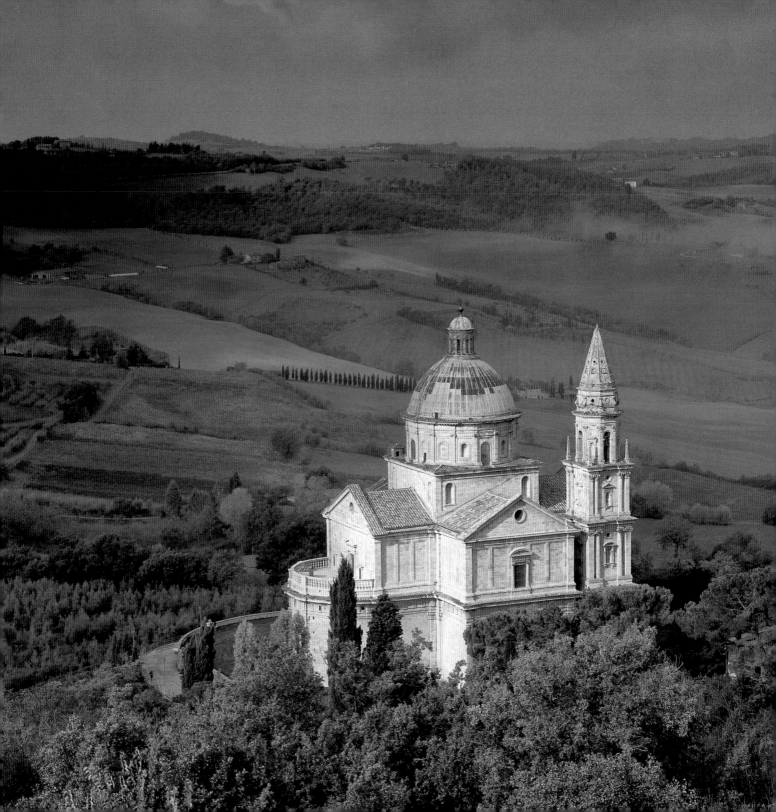

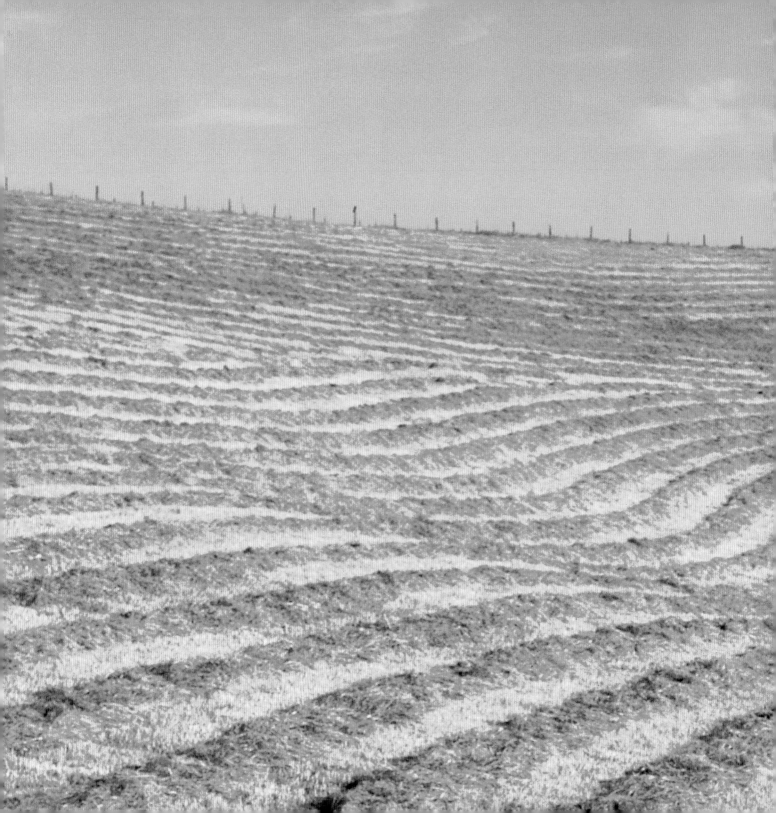

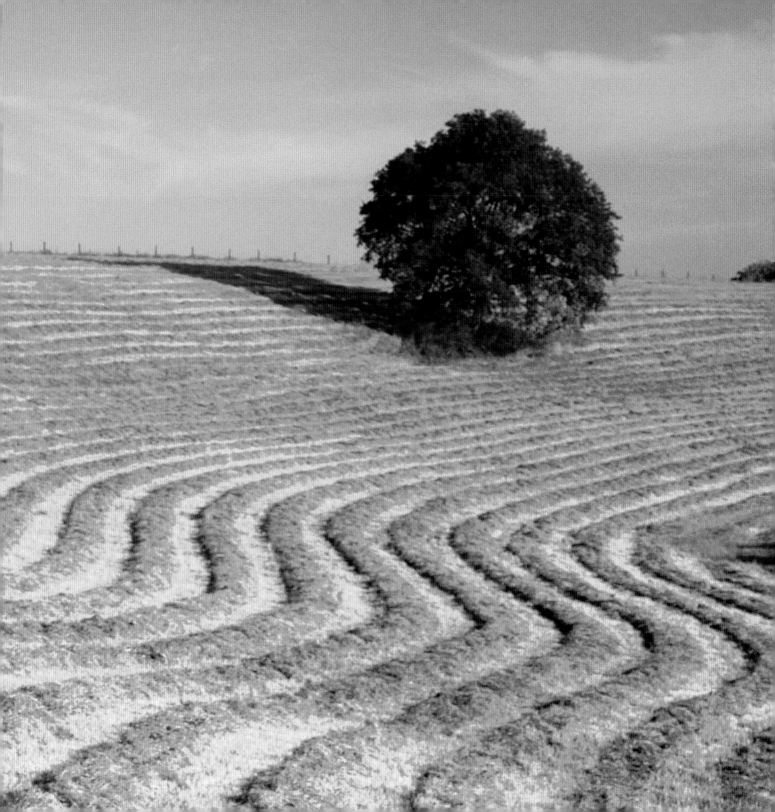

Flavor is what I miss whenever I leave Italy and what I seek as soon as I come back. It is a hard thing to describe; still, when something tastes the way it ought to, you recognize it instantly—authenticity always being a self-defining experience. Arugula and olive oil, cherries and figs, *proscuitto di Parma*, sliced into transparent sheets, then draped over a wedge of melon: such foods announce themselves quietly, with assurance; then, just as quietly, they amaze the tongue. Even the Italian flag plays homage to this principle, for what do the red, green, and white stripes represent, if not tomato, basil, and mozzarella?

DAVID LEAVITT

A Pecorino and sausage shop in Pienza displays its delicious wares. Items purchased here can be shrink-wrapped and carried home in your suitcase.

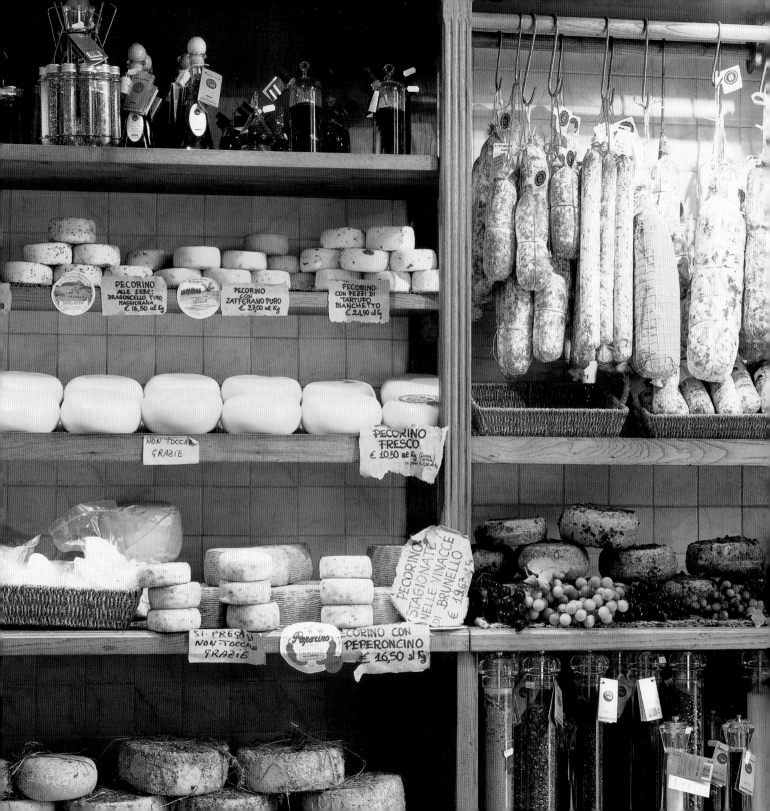

Y ou may have the universe if I may have Italy.

GIUSEPPE VERDI

Perched at the top of a hill in the countryside surrounding San Quirico D'Orcia, this little building—Capella di Vitaleta—was built centuries ago as a private chapel but sits abandoned today. The distinctive structure is now surrounded by wheat fields and grazing sheep after the wheat harvest.

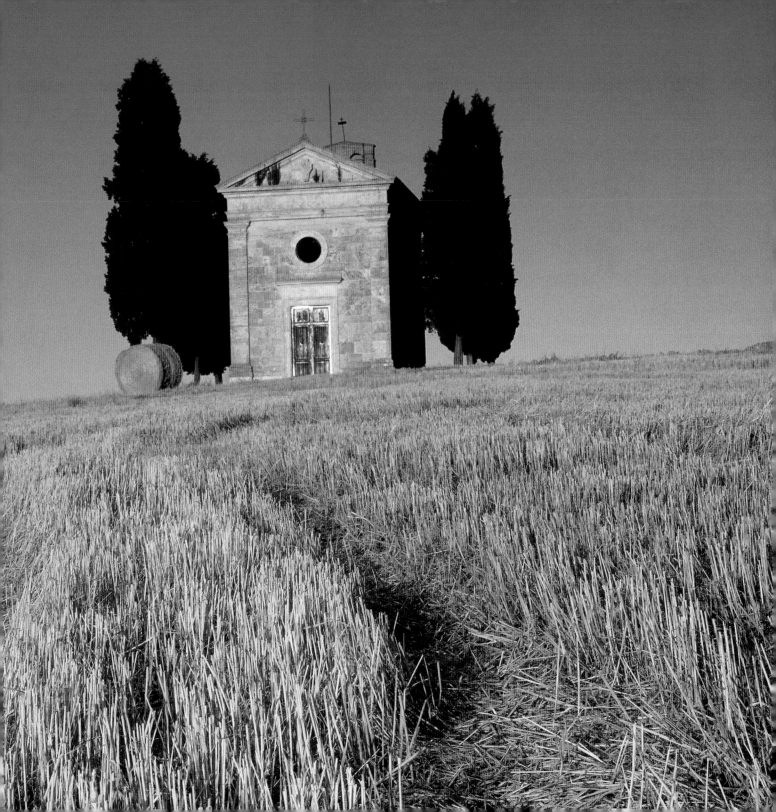

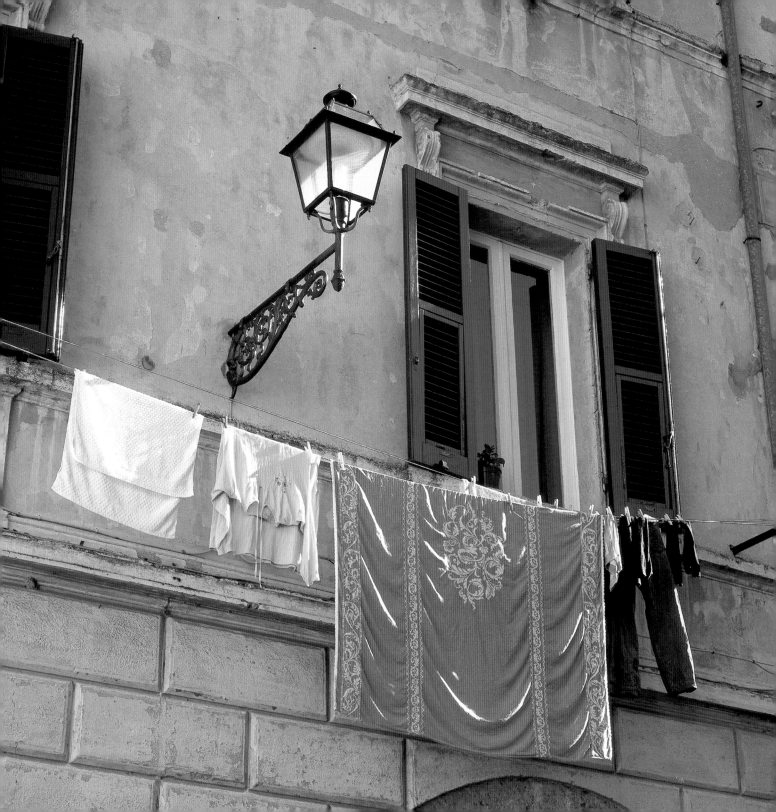

What do we find in Italy that can be found nowhere else? I believe it is a certain permission to be human that other countries lost long ago.

ERICA JONG

One of the most colorful sights among this area's hilltop villages is laundry adorning the walls of the houses, drying in the sun. It's a common sight in the narrow streets of Pitigliano, a majestic little town built on a hill of volcanic tufa. Beneath the settlement are caves in the cliff face; once Etruscan tombs, they're now used as stables and storehouses for wine and olive oil.

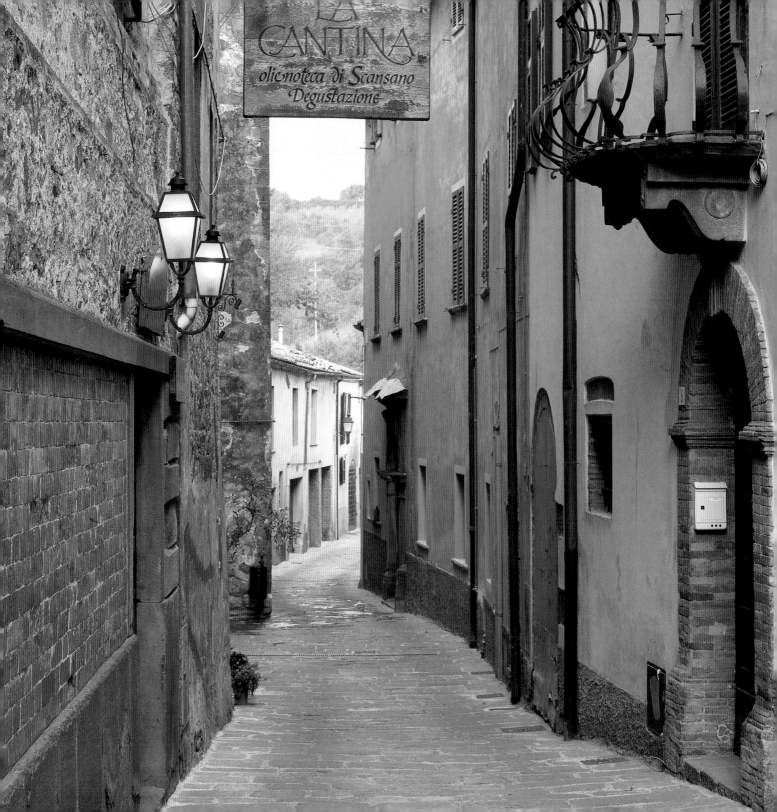

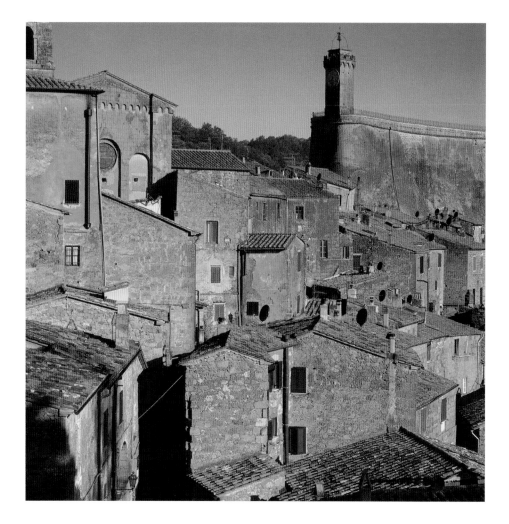

OPPOSITE: Scansano is perched on the hilly island of Maremma, along a strip of land between the coast and the slopes of Mount Amiata. The town is famous for producing one of the best DOC (Denominazione di Origine Controllata) wines in Italy, the Morellino di Scansano. La Cantina is a great spot for a wine tasting.

ABOVE: As we approached Sorano from the east with the early-morning light, a warm glow lit up the stone houses climbing the tufa hillside. This medieval village was built on a tufa outcrop, an ancient Etruscan site above a deep ravine with a roaring stream and waterfall. Though it's still inhabited, many of the buildings have begun to collapse into the surrounding valleys. A number of fine shops here display the goods of local craftsmen and artists, including fashionable clothing and products made of olive wood.

Italians live in a land with many layers of history. They walk on stones worn smooth by the feet of Etruscans, Romans and Saracens who came before them. They think nothing of it. They live with centuries of history piled up visibly in the walls and stone cathedrals of every little town.

CAROL FIELD

When we first arrived at Agriturismo Terrapille, a spring storm was just clearing, creating a spotlight of Tuscan sun on Pienza. We found Pienza to be one of our favorite hilltop villages, with several wonderful restaurants. In fall, at La Buca delle Fate, we ordered giant porcini mushrooms, which were picked from a silver tray brought to the table then roasted in the oven with olive oil and seasoning. We enjoyed this with a fine Vin Nobile from nearby Montepulciano.

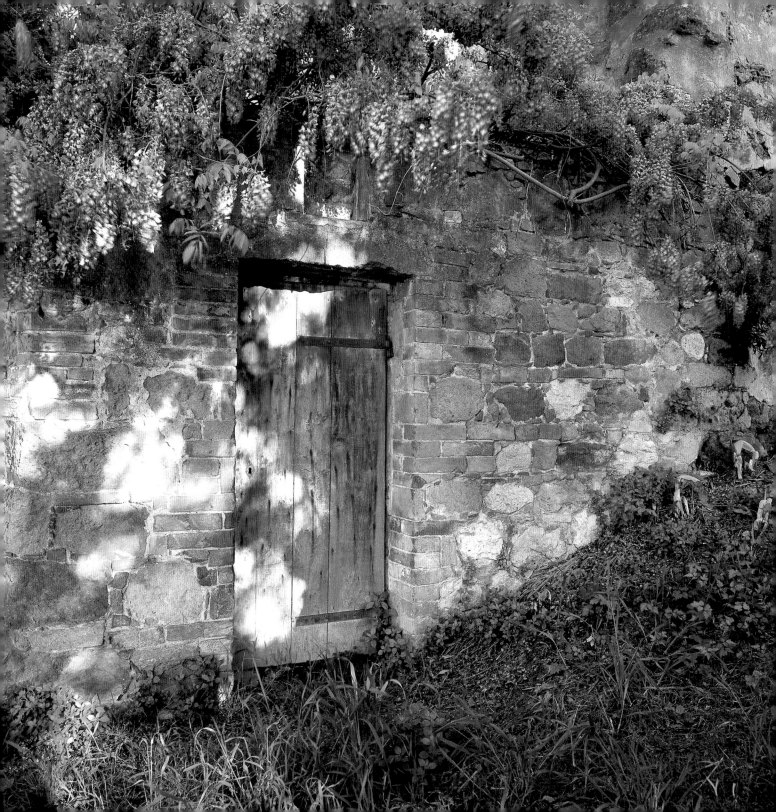

Overhead and on all sides a bower
of green and tangled thicket, still fragrant
and still flower-bespangled.

ROBERT LOUIS STEVENSON

Beneath the Duomo in the Piazza Pio is a small storehouse carved into the tufa cliff. On an early-morning walk we found a wisteria vine in full bloom adorning the storehouse, which was likely originally an ancient Etruscan cave right below the cathedral.

Traveling is the ruin of all happiness!

There's no looking at a building after seeing Italy.

FANNY BARNEY

Montisi, a small village that was once a Cacciaconti fortress, is a relic of medieval Italy offering winding alleyways, views of the two nearby valleys, two small Romanesque churches, and surprisingly delightful sights such as the one pictured here. Wandering about inside the walls of the village, I came across this wonderful image with the quintessential Tuscan colors of terra-cotta, golds, and greens. Visit the butcher shop to see how sausages and prosciutto are made.

A whole people, the product of civilized time past, the product of the dramatic landscape, the Tuscans are also progenitors of what one finds there. It is their spirit of endurance and rejoicing in the goodness of life that inspired the architecture, the paintings, the churches and those ancient cultures of olive groves and vineyards which are the essence of Tuscany.

MURIEL SPARK

Located a few kilometers from Montalcino, the Sant'Antimo abbey stands alone in a valley filled with ancient olive groves and recently planted vineyards that supply grapes for the famous Brunellos of the region. Constructed from native travertine, the structure glows in the early-morning sun. Inside, you can listen to the sacred music and Mass sung by the priests in Gregorian chant.

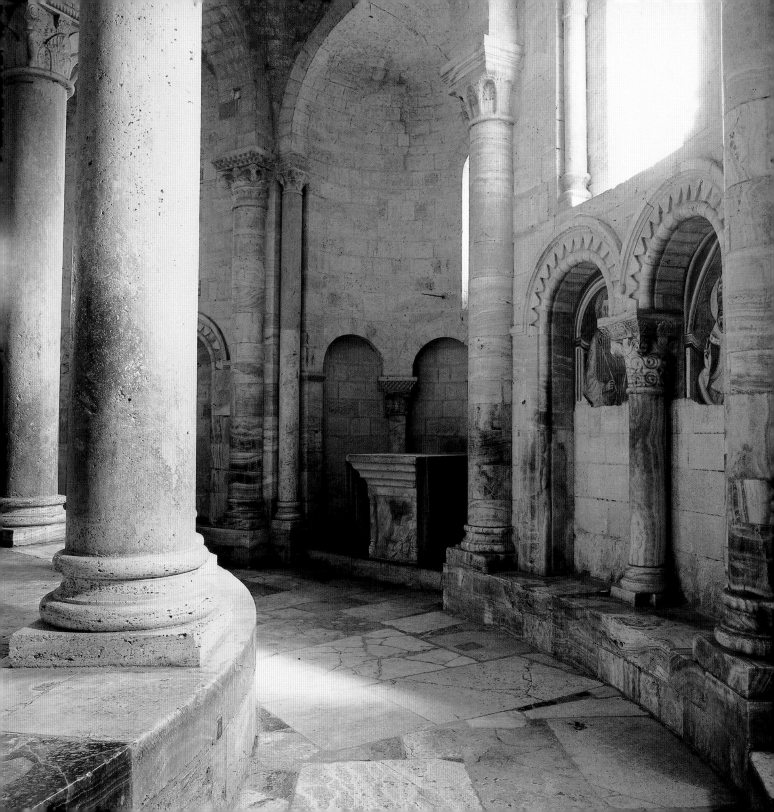

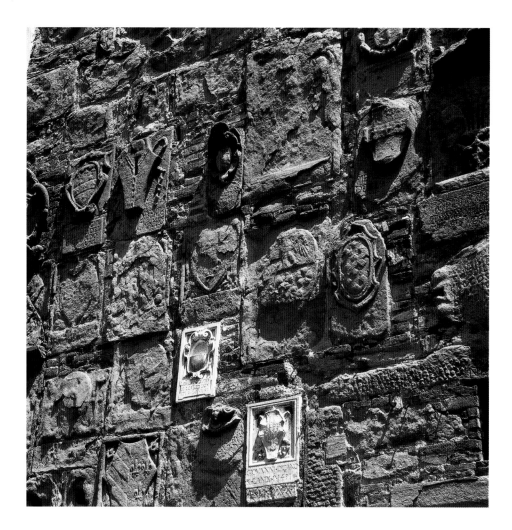

ABOVE: On the town hall of each Tuscan village, the history of its citizens can be traced from the family crests that go back for centuries. In this region the Medici family ruled during ancient times.

OPPOSITE: A Renaissance well stands on the far side of the Piazza Grande, the highest point in Montepulciano. The well is adorned with the Medici family crest in the stonework on top. Piazza Grande becomes a stage for concerts and the International Arts Workshop in July and August each year, staging musical shows, theater productions, and exhibitions of figurative art. If you're there at the end of August, you might be lucky enough to catch the community's best production, the Bravio della Botti—a competition among the contrade, the different districts of the town. Locals process in fourteenth-century dress and roll empty wine barrels through town in a race that ends at Piazza Grande.

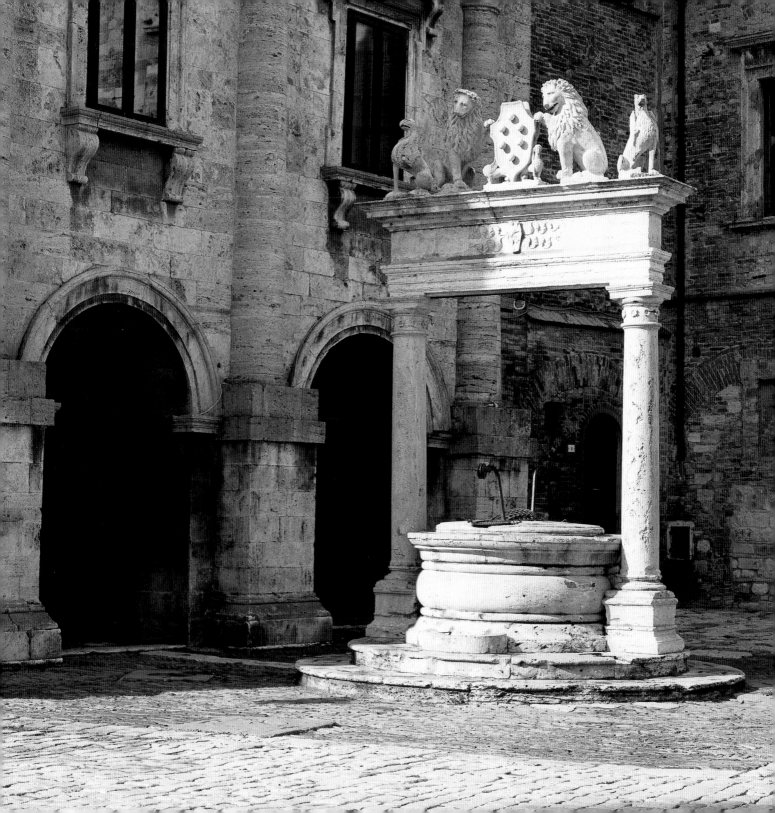

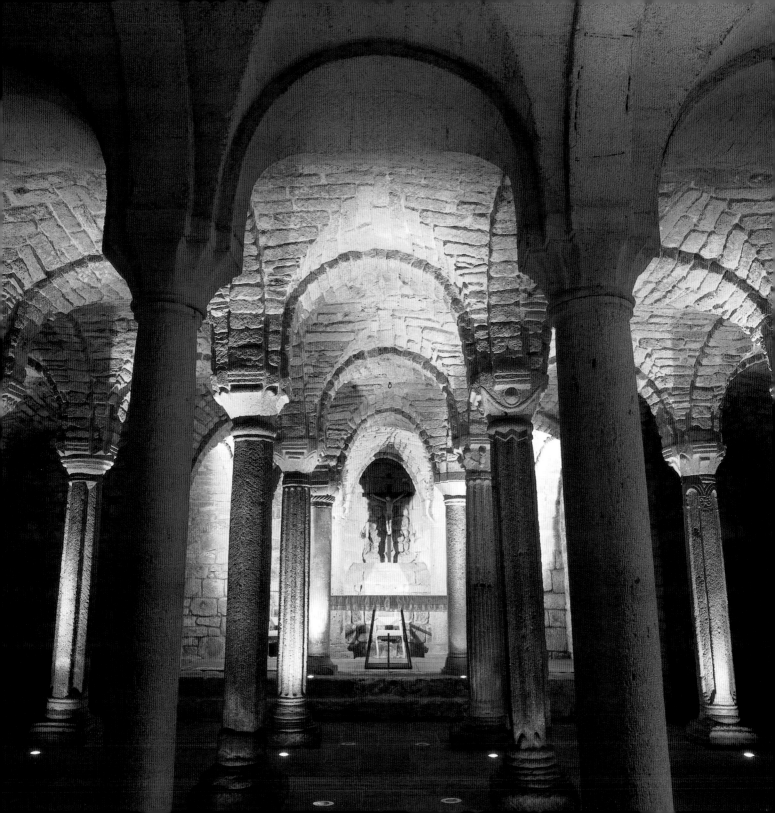

OPPOSITE: A view of the majestic crypt that lies beneath the Abbadia San Salvatore. According to legend, Lombard king Rachis founded the abbey in 743 on the precise spot where he had seen a vision of the Savior. The crypt itself is most likely the original pre-Romanesque church, divided into thirteen aisles with a vaulted ceiling and substantial columns, many of which are richly decorated.

ABOVE: I was drawn to this striking figure of the Madonna surrounded by candlelight and the natural light from a nearby window in Abbadia San Salvatore, on the eastern slope of Mount Amiato. Today the town—named for the abbey—is a modest mountain resort and a gateway to Mount Amiato. But in the year 1000, the abbey had already achieved considerable wealth and influence and was considered the most important monastic center in the region. The present church was built atop the original building's site in 1036, a Romanesque structure that in its time was likely one of the grandest in Tuscany.

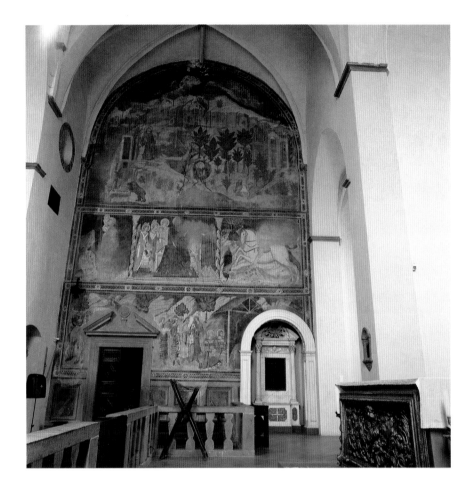

ABOVE: A large fresco in the Gothic church of San Francesco in Lucignano, painted by Sienese artists Bartolo di Fredi and Taddeo di Bartolo. As we were leaving the cathedral, an opera company was setting up chairs for a production of Don Giovanni—part of a Mozart festival to be presented in the Piazza del Tribunale.

OPPOSITE: A fresco detail from San Francesco in Lucignano. While I was photographing inside, a youth choir was rehearsing for an upcoming event, filling the huge cathedral with glorious sound.

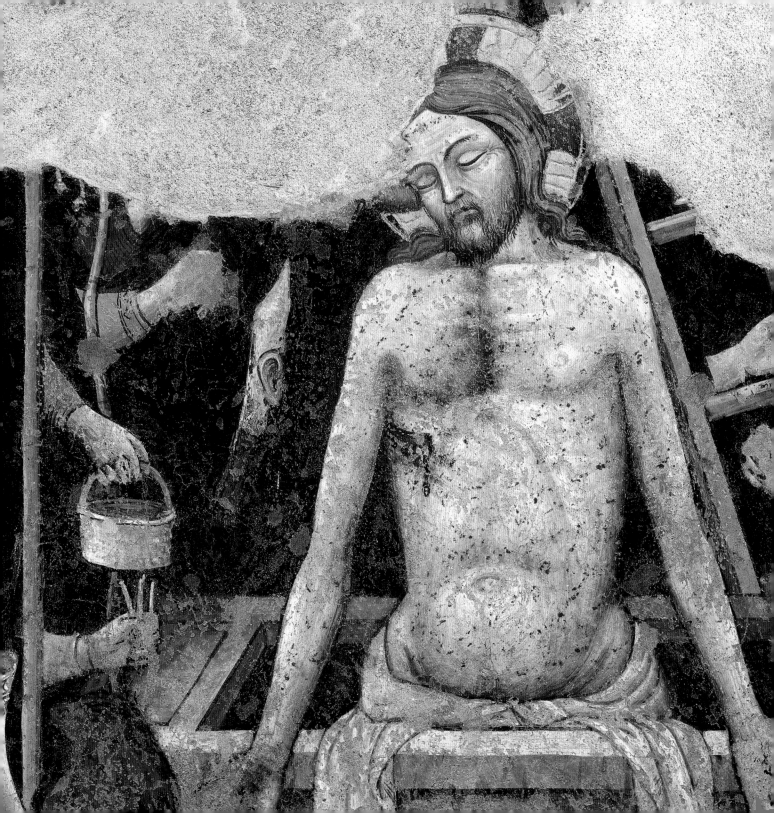

The wind swept over the Campagna, howling among the lower hills as if portending an earthquake. Above the barren mountain-tops, murky and threatening with the shadow of the coming storm, lay Monte Oliveto Maggiore, twenty-five miles from Siena, the principal Benedictine establishment of Central Italy.

FRANCES MINTO ELLIOT

OPPOSITE: Monte Oliveto Maggiore—built in the fifteenth century—is a stunning abbey perched on the top of a cliff in the Crete Senesi area. Monks currently live on the premises, and the church is used for religious purposes. The Great Cloister beside the church features a famous fresco series about the life of Saint Benedict by painters Signorelli and Sodoma. The abbey closes during midday hours, so be sure to arrive well before noon or in the later afternoon.

OVERLEAF: In the Crete Senesi, just south of Pienza, Sardinian sheep graze on endless fields of alfalfa, providing milk for the region's famed Pecorino cheese. Lucia led us to nearby Azienda Agricola San Paolo, where more than six hundred sheep graze in their pastures and the finest of Pecorinos are produced. We had several of the cheeses shrink-wrapped to enjoy at home!

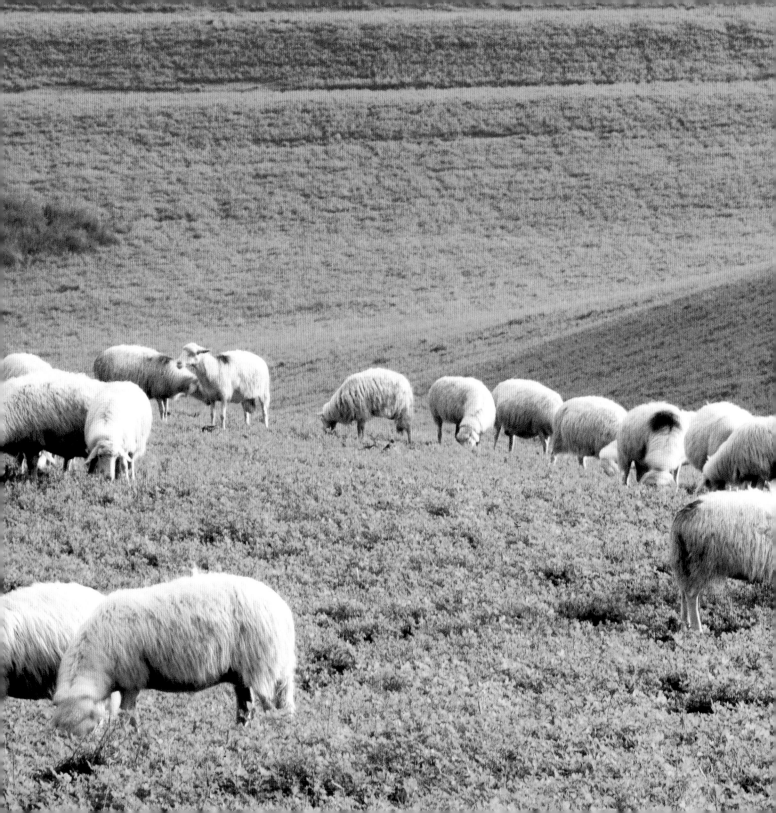

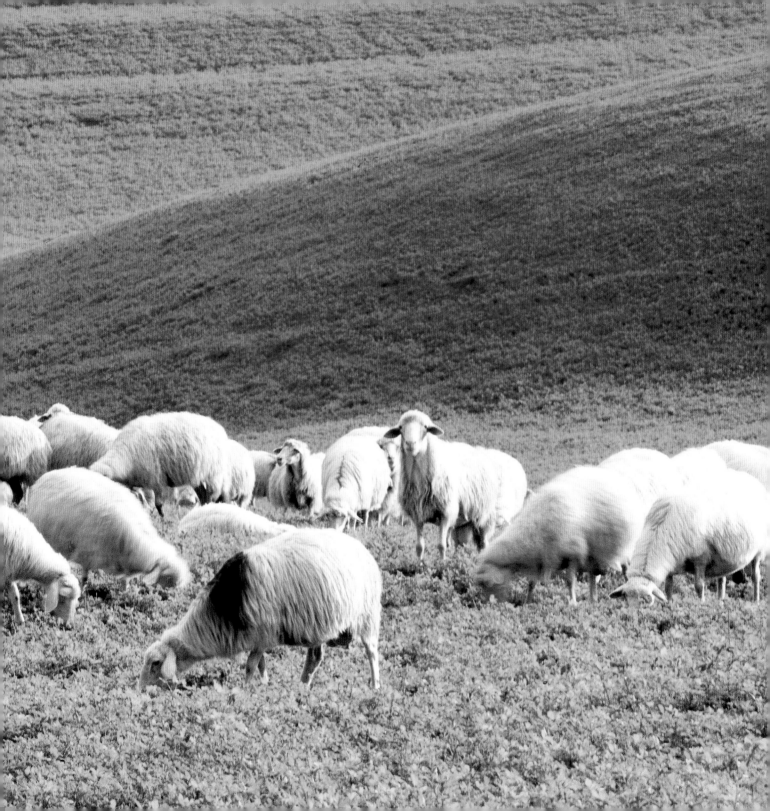

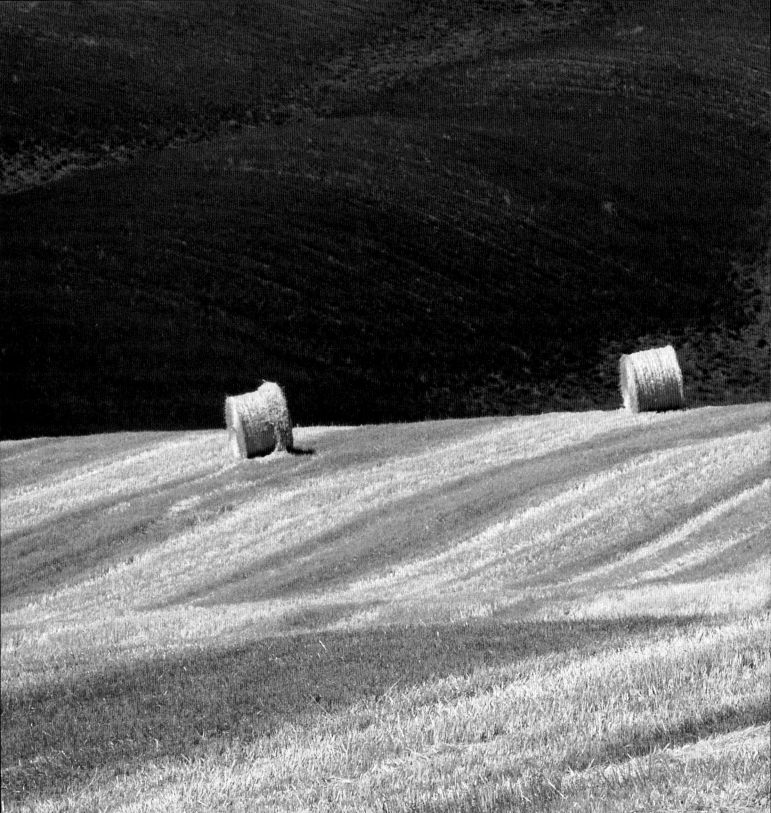

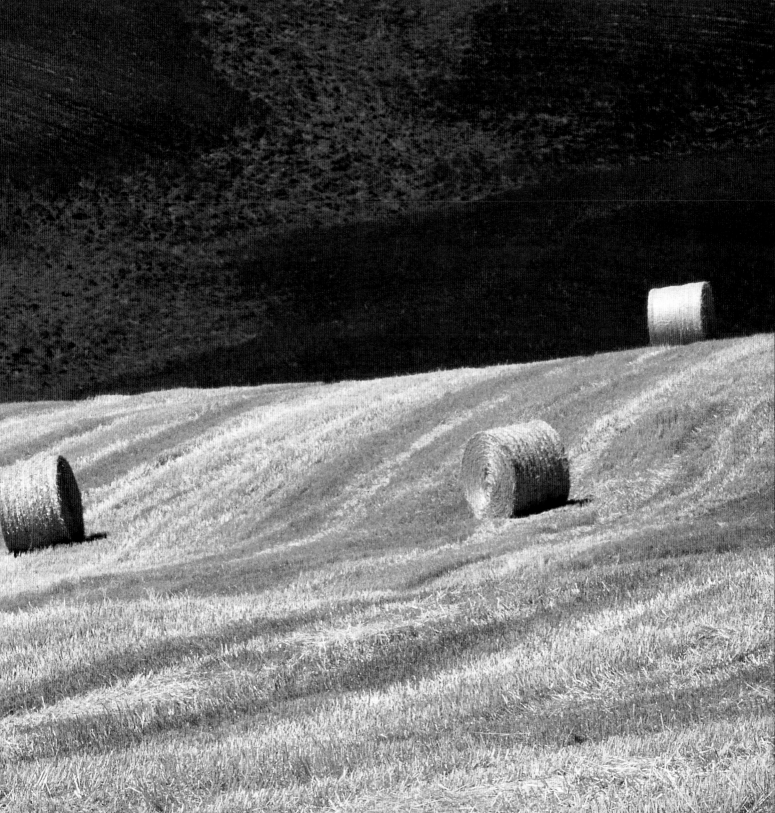

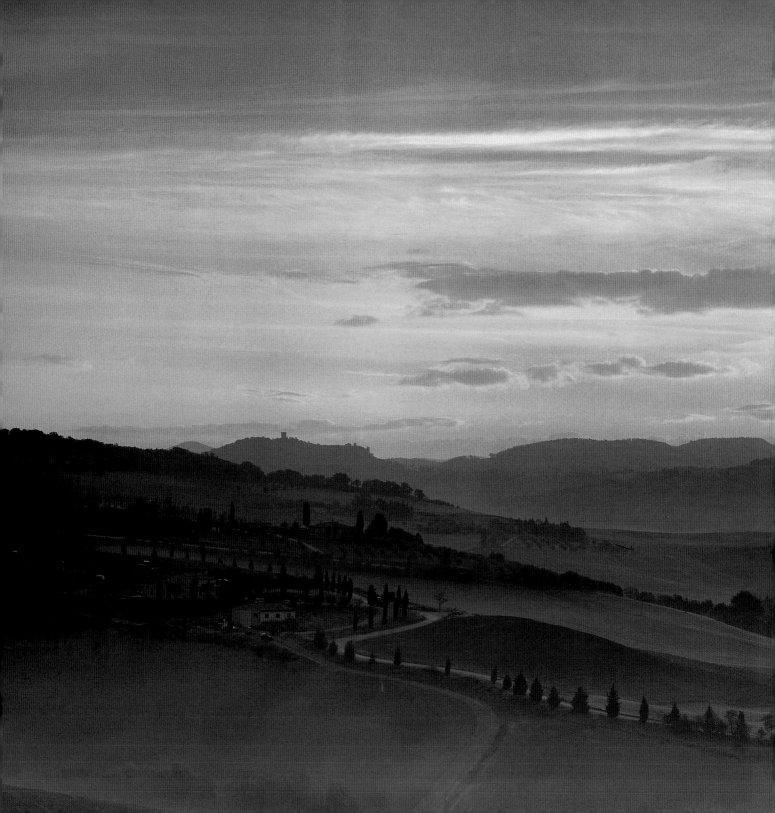

From Tuscan Bellosguardo,

Where Galileo stood at nights to take

The vision of the stars, we have found it hard,

Gazing upon the earth and heavens, to make

A choice of beauty.

ELIZABETH BARRETT BROWNING

PRECEDING SPREAD: During our stay at Agriturismo Terrapille, Guilano was cutting and rolling wheat straw into large rolls for sale as feed. These were offset by the chocolate brown of the alfalfa that had gone to seed, providing next season's food for the flocks on the hills around Pienza.

OPPOSITE: At Terrapille, the Val D'Orcia was filled with predawn fog. As it lifted, Montecchiello came into view on the distant hilltop.

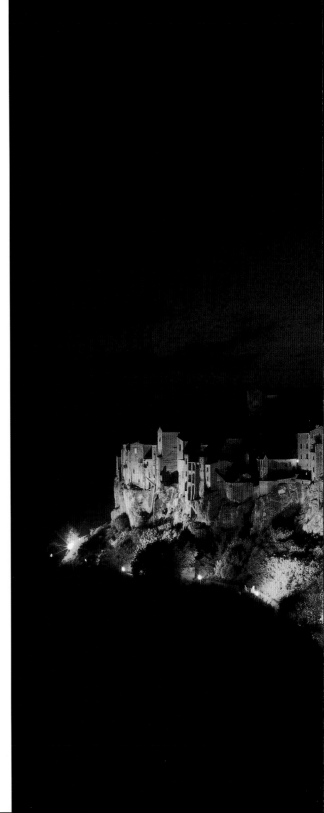

Lately, during the misty autumn nights, the moon has shone on them faintly and refined their shabbiness away into something ineffably strange and spectral. The turbid stream sweeps along without a sound, and the pale tenements hang above it like a vague miasmatic exhalation. The dimmest back-scene at the opera when the tenor is singing his sweetest, seems hardly to belong to a world more detached from responsibility.

HENRY JAMES

On our last evening before we left Tuscany for Rome, and home, we had dinner at a small trattoria next to the aqueduct in Pitigliano. As we departed the restaurant, the sky was not quite dark, complementing the new moon with a dark blue background. A wonderful end to our travels.

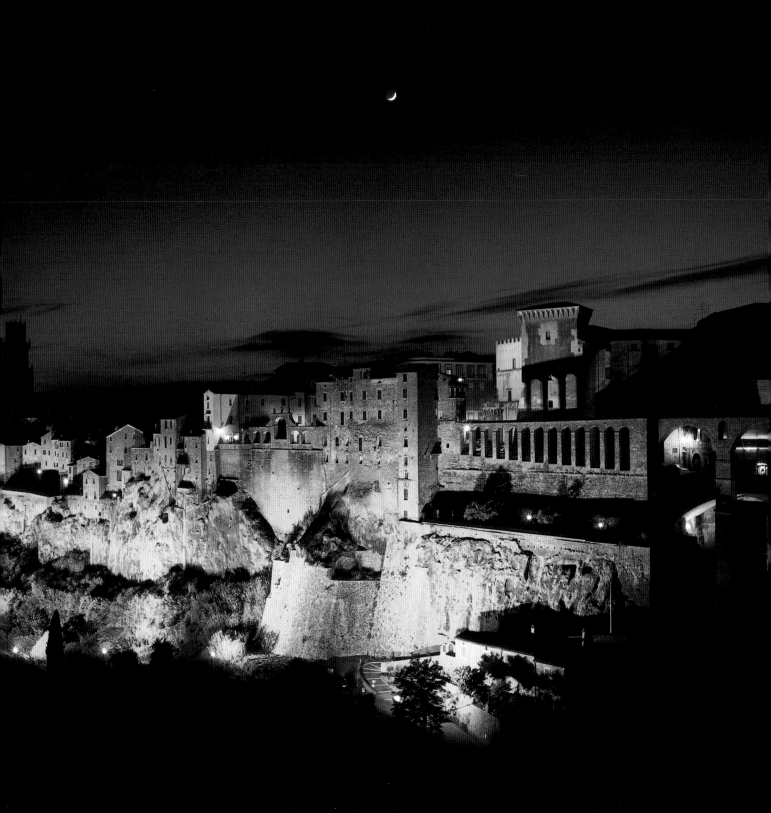

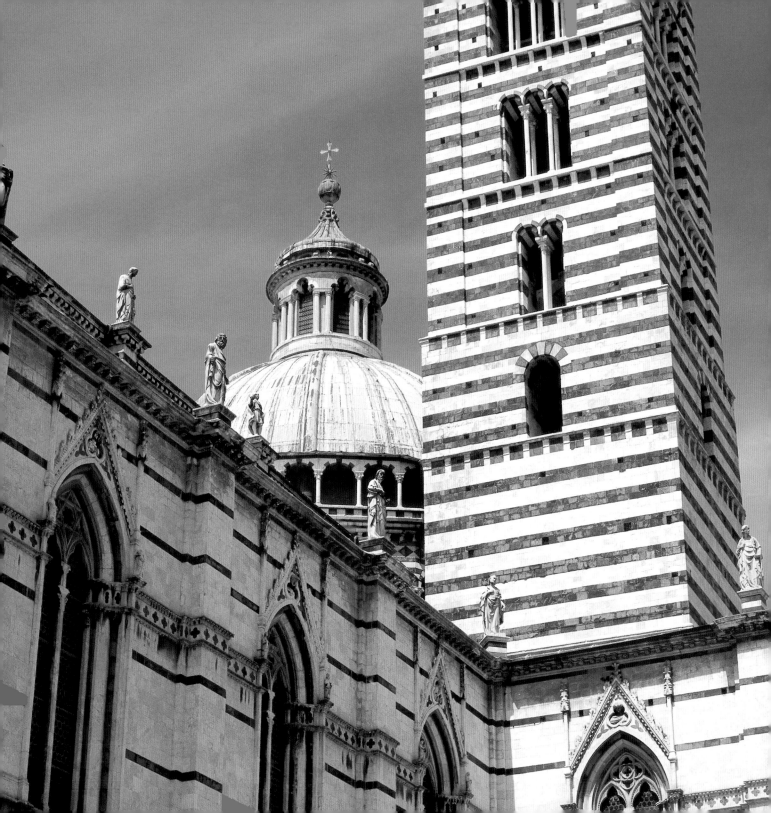

THE HILL TOWNS

V

Out on the road a three-wheeled Ape comes chugging by. We wave it down and motion into its open back and Candace says, *"Un passaggio, per favore,"* and points to the top of the hill. The dusty bricklayer laughs and waves us aboard. The Ape chug-chugs feistily ahead. On the hilltop before a small cemetery we knock, get off and wave good-bye. We walk into the olive grove and sit in the dry grass on the bluff. The monastery and the whole world lie before us. Purples, yellows, pinks and blues but all washed, hazy, indefinite, dreamy. The world was dissolving, vanishing. And if you half-closed your eyes, you could see yourself from afar, dissolving in the haze. You could see yourself turning into light.

FERENC MÁTÉ

PRECEDING SPREAD: Siena's famous Duomo, a magnificent Gothic structure, was started in the early thirteenth century as a round-arched Romanesque church, but soon acquired an elaborate Gothic facade. Bands of black, white, and green marble are inlaid with pink stone and create a striking image, particularly along the campanile that rises dramatically over the city.

OPPOSITE: In spring, while traveling the road from San Galgano toward Siena, we passed through rolling hills of wheat and came upon the imposing structures of San Lorenzo a Merse standing alone on a hilltop.

Nothing is new in Tuscany, we were merely the latest of those
who had laughed and joked upon that hilltop under the same blue sky.

H.V. MORTON

OPPOSITE: A red poppy field in San Quirico D'Orcia.

OVERLEAF: Looking west from a hilltop adjoining Monteriggioni, the terrain is gently rolling; fields of wheat and corn emerge in springtime. The steeper slopes, undisturbed by cultivation, are covered with a profusion of red poppies. The small village of Abbadia Isole can be seen in the distance across the Val D'Elsa.

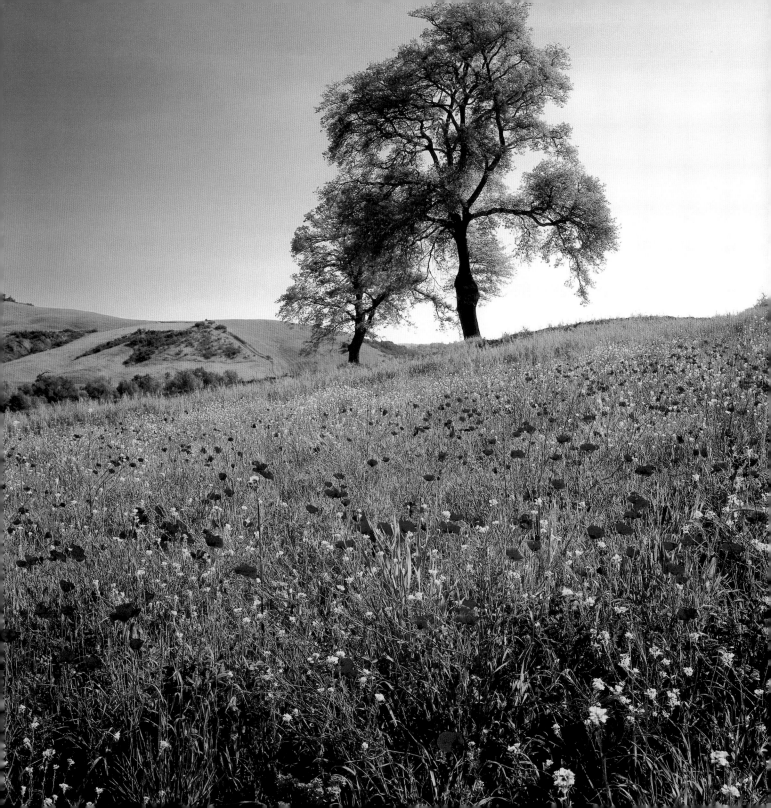

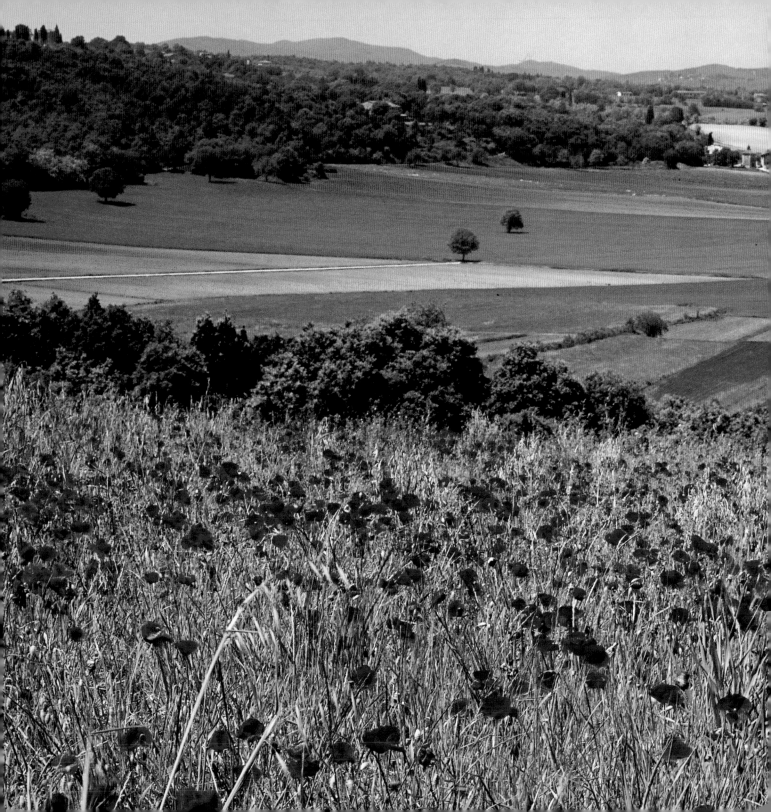

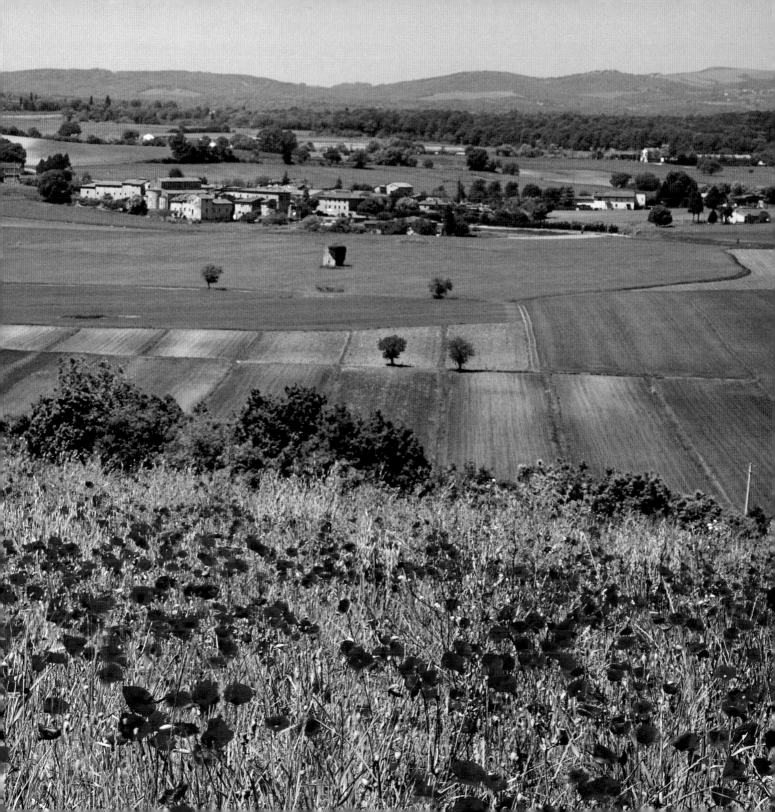

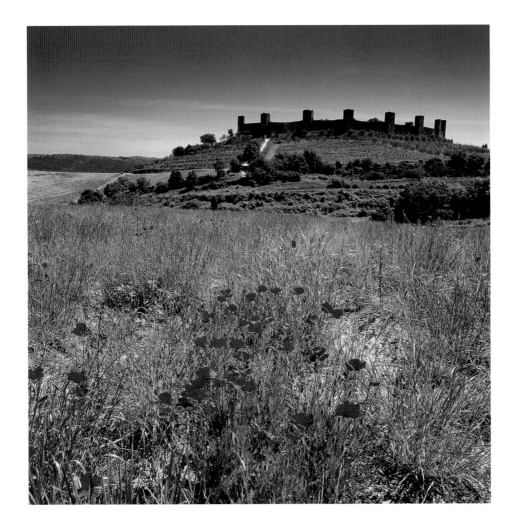

ABOVE: This hilltop town was once a Sienese defensive outpost, fortified against the Florentines. Today, steeped in antiquity, it provides vistas over the gentle hills of the Sienese countryside. In May fields of red poppies trail off to the west.

OPPOSITE: In late April and early May the countryside in the Crete Senesi is filled with wildflowers, the most spectacular of which is the red poppy. Over the years, with extensive cultivation of the land, poppies have become scarce, yet they can still be found in pockets and are always a joy.

O*liva e oro, la seconda argento, la terza mon val niente.*

Olive is gold, the second silver, the third is worth nothing.

TUSCAN SAYING

A farm planted in the rich red soil of the Sienese countryside. Wheat, sunflowers, and olive trees flourish.

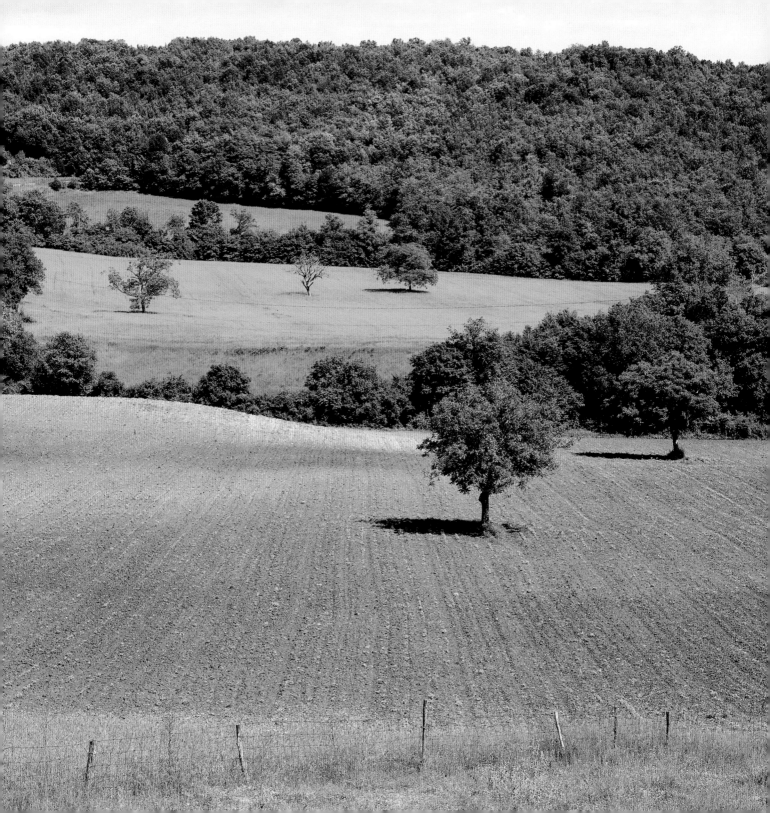

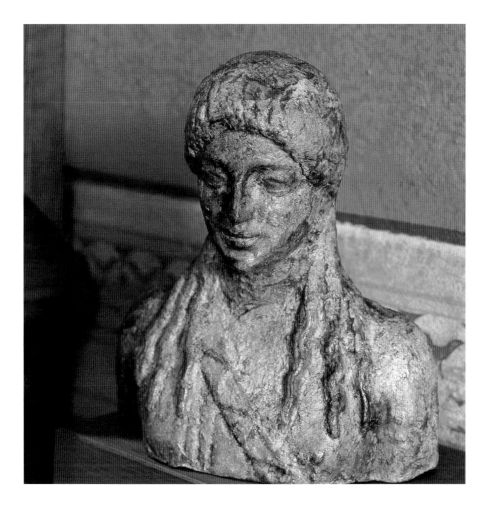

OPPOSITE: The Castelletto di Montebenichi is one of the finest hotels in Tuscany. The sitting room is filled with beautiful art and ancient Etruscan pieces. The hotel itself is sited on a spectacular hilltop, very much out of the way and undiscovered.

ABOVE: Among the many beautiful things inside, you'll find this stunning Etruscan bronze from the sixth century BC.

OVERLEAF: San Gimignano's famous skyline is best appreciated from the approaching roads into town. Of the city's original seventy-plus towers, only fourteen remain, but together with the surrounding streets, churches, and outlying vineyards, these remaining towers are enough to give the visitor a sense of San Gimignano's grande and powerful stature during its prime.

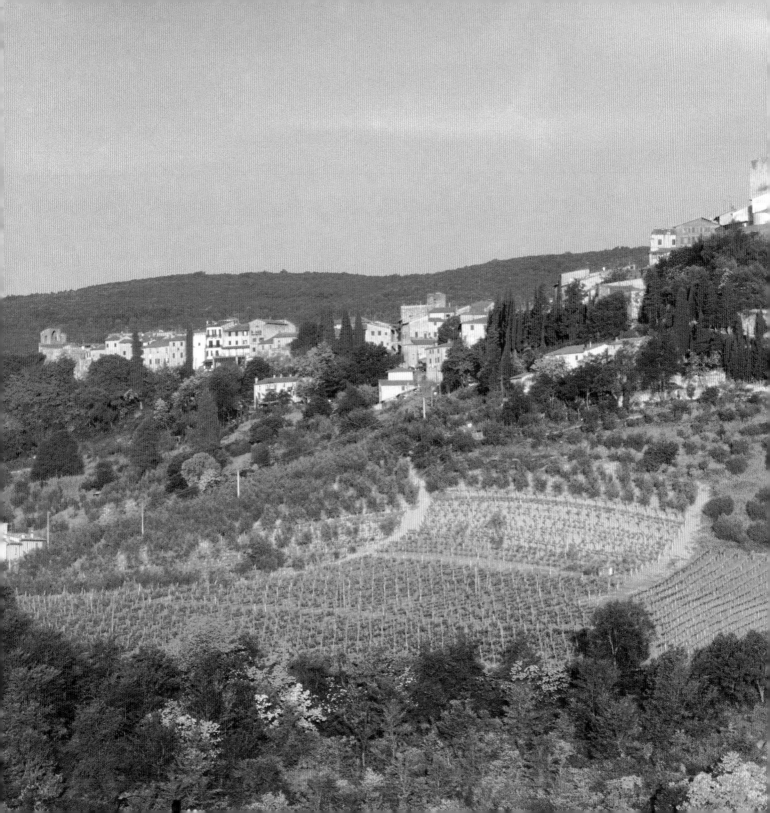

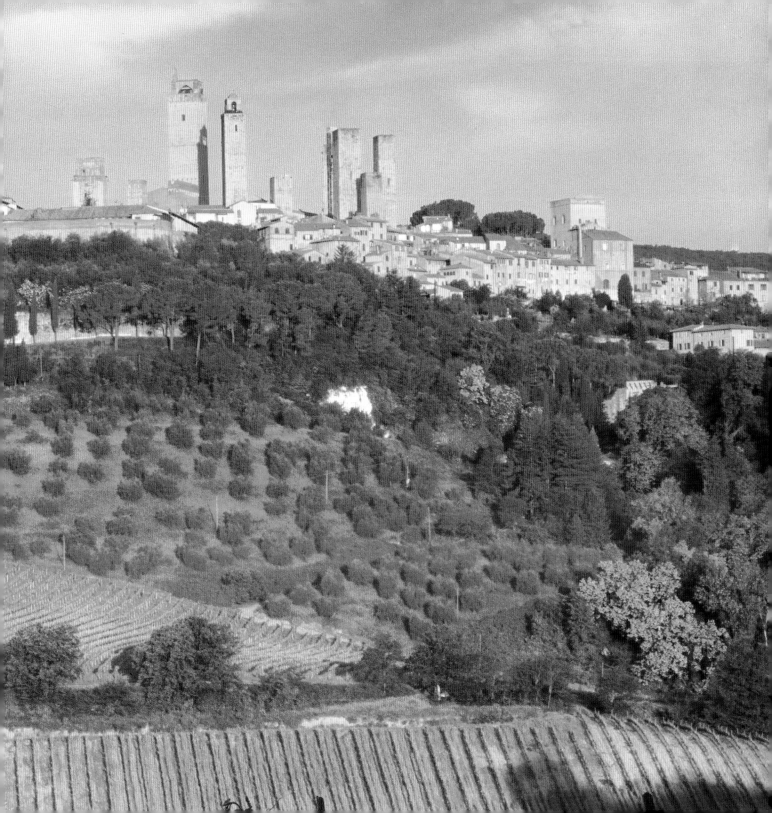

Today we saw the most beautiful of views and the melancholy man. The view was like a line of poetry that makes itself, the shaped hill, all flushed with reds and greens; the elongated lines, cultivated every inch; old, wild, perfectly said, once and for all.

VIRGINIA WOOLF

OPPOSITE: To the southeast of San Gimignano, toward Montauto, lies the village of Piano with its sinuous lane of cypress trees leading up the hillside. In midsummer the valley below is filled with sunflower fields stitched into a stunning golden landscape.

OVERLEAF: This field of sunflowers in the Crete Senesi region south of Siena is a common view throughout spring and summer in Tuscany, but each time we passed such a brilliant and colorful field we were no less impressed by its beauty.

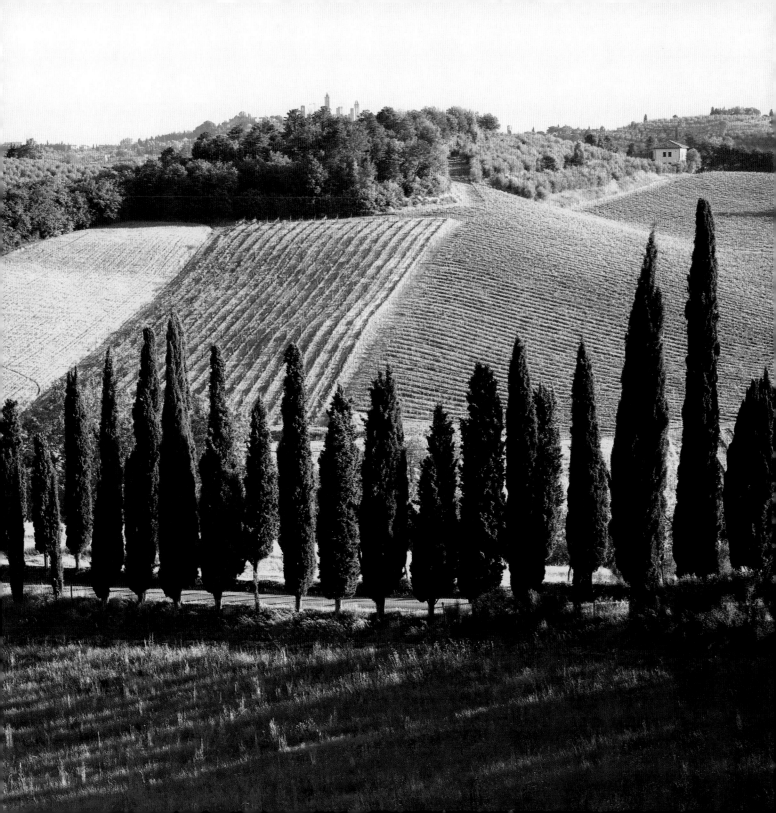

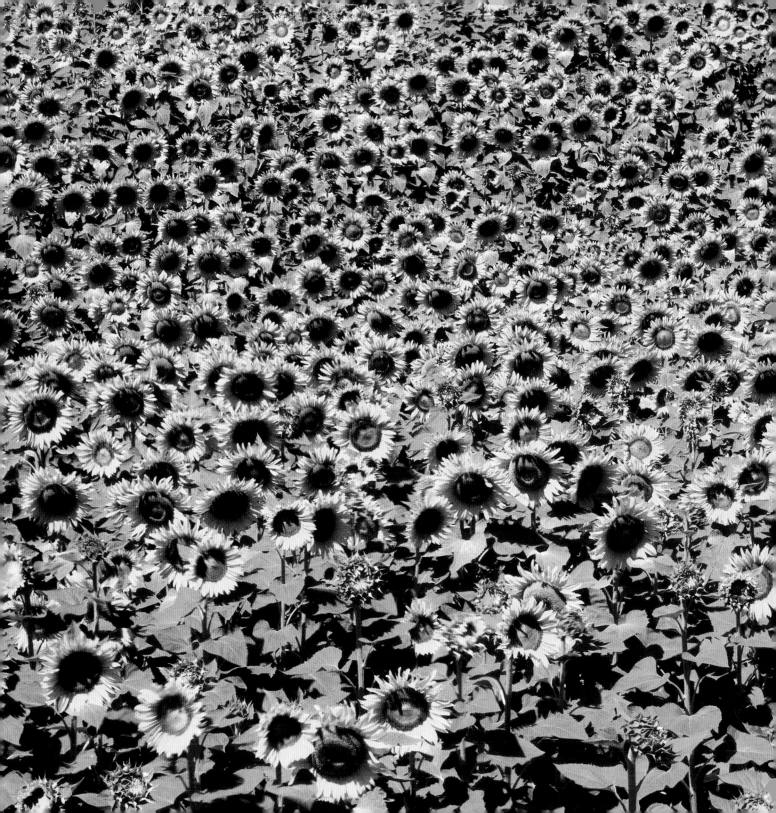

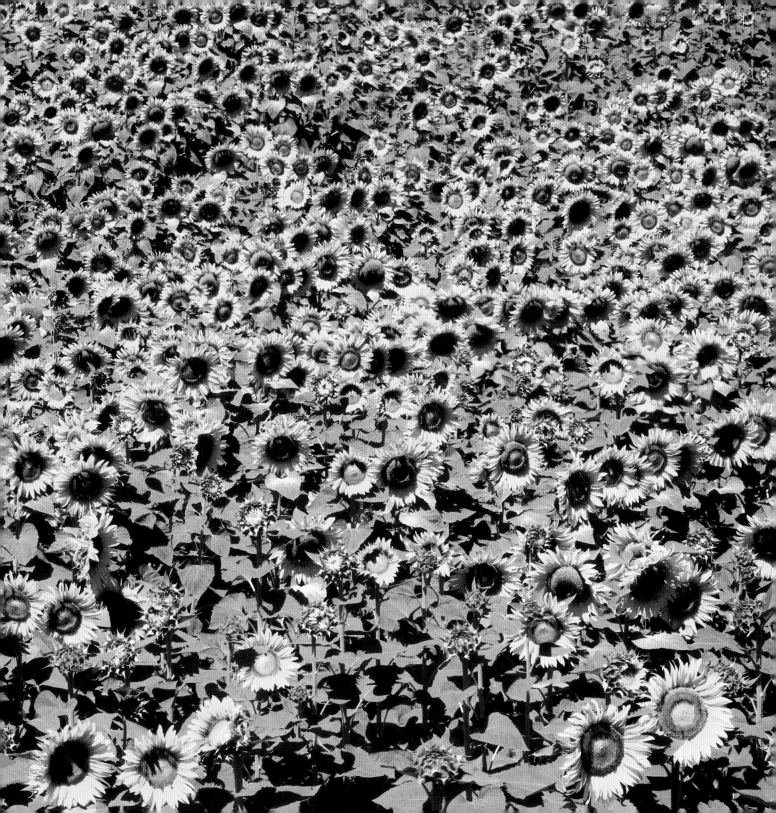

Wine is a look into the heart of a place.

KAREN MACNEIL

We spent the early evening on a hillside while enjoying a picnic of Pecorino, prosciutto, olives, and bread as the sun dropped behind the hilltop town of San Gimignano. With a bottle of the local red, of course!

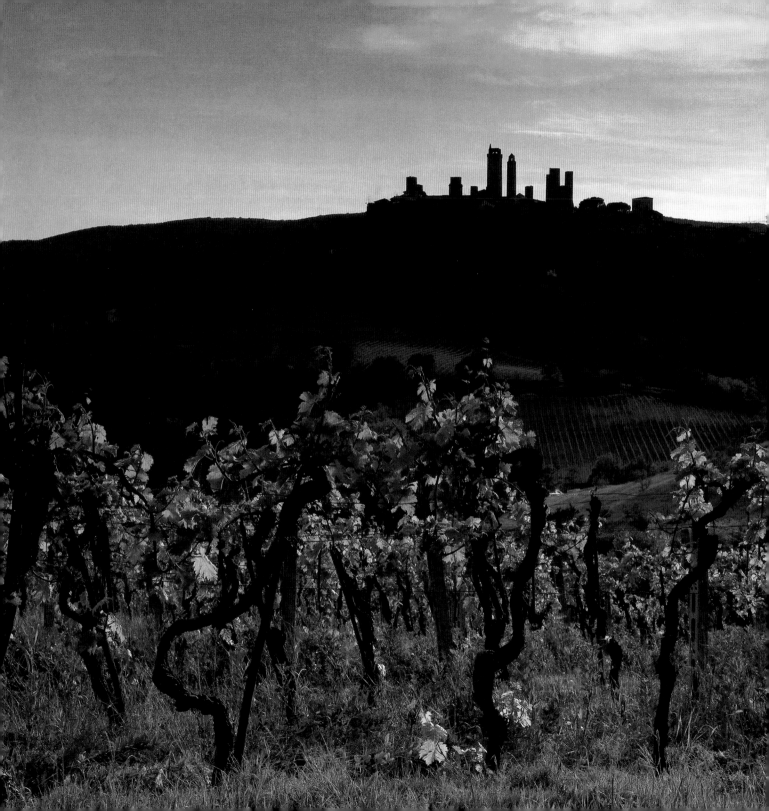

VI

THE TUSCAN COAST

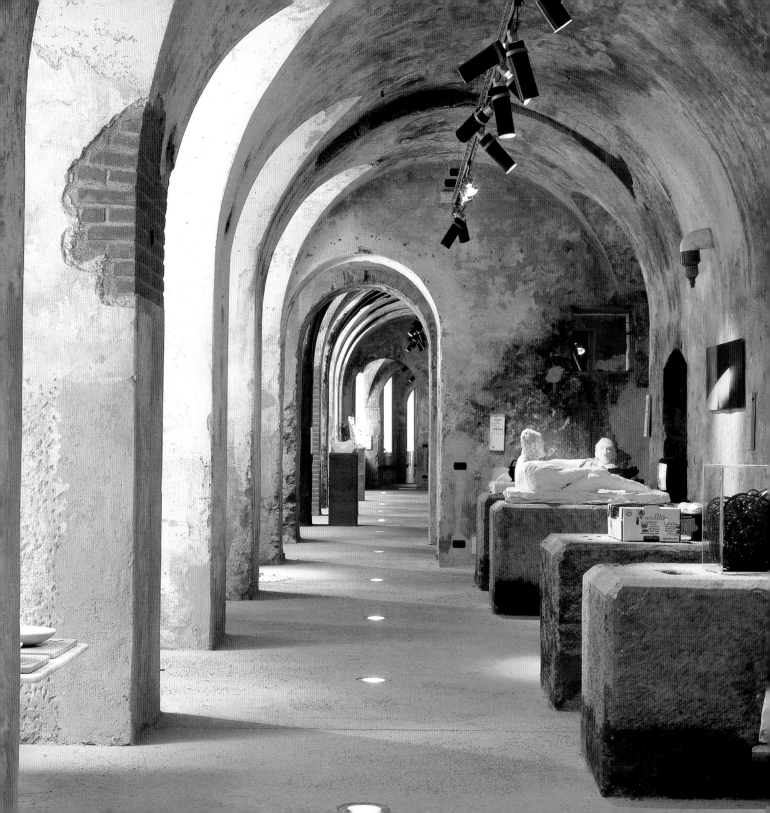

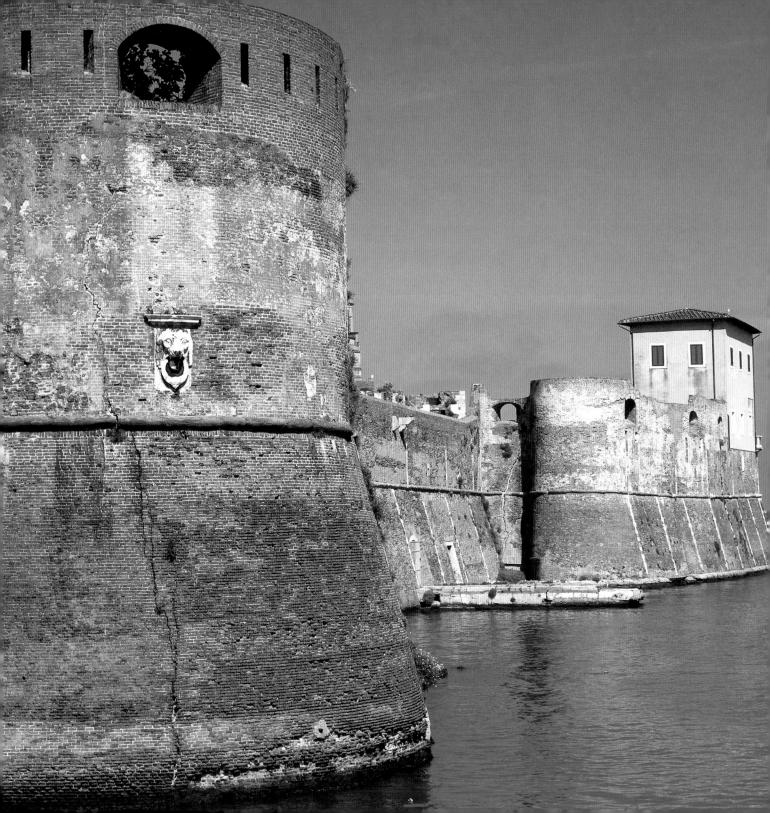

And then there is the sea. One seldom thinks of the sea when one thinks of Tuscany, conjuring instead its inland sea of hills, forgetting the long coast on the Tyrrhenian, with vast uninhabited stretches, dark pine forests, cliffs, and the medieval harbors of sailboats and fishing boats with their bows anchored to sea. The tiny houses, shoulder to shoulder on the hills and bluffs, gaze down at the transparent water whose hues shift with the rising and fading light.

FERENC MÁTÉ

PRECEDING SPREAD: The art gallery of the Arkad Foundation in Seravezza is located next to the ancient trout ponds of a palace commissioned by Cosimo de' Medici, duke of Florence, in order to control the extraction of marble from nearby Monte Altissimo. This marble was reputed to have been discovered by Michelangelo and the medium of some of his sculptures. We arrived in time to see a wonderful exhibition of local and international artists in the gallery.

OPPOSITE: Near the entrance to the Livorno port on Piazza Micheli, the crumbling redbrick Fortezza Vecchia—an impressive pentagonal structure surrounded by moats and built by Antonio da Sangallo for Cardinal Giulio de' Medici between 1521 and 1534—conceals the original Pisan fortress and Mástio di Matilde, an eleventh-century tower built by Countess Matilda.

The sun is snared

In the airy cages of the fruit trees,

Revealing the gold fur along their branches,

Throwing down golden rings

To quiver in the water

In grotto and fountain.

OSBERT SITWELL

Overlooking the half-moon crescent of Golfo di Baratti lie the substantial remains of Populonia, the last of the twelve Etruscan cities to be constructed. In the sixth century BC Populonia was the first Etruscan city to mint gold, silver, and bronze coins, often featuring a lion's head. Many of the tombs that house these wares lie buried or collapsed under the weight of ancient slag heaps. Modern Populonia has an impressive medieval castle and small archaeological museum. Visitors are able to explore what remains of the Etruscan city and tomb ruins.

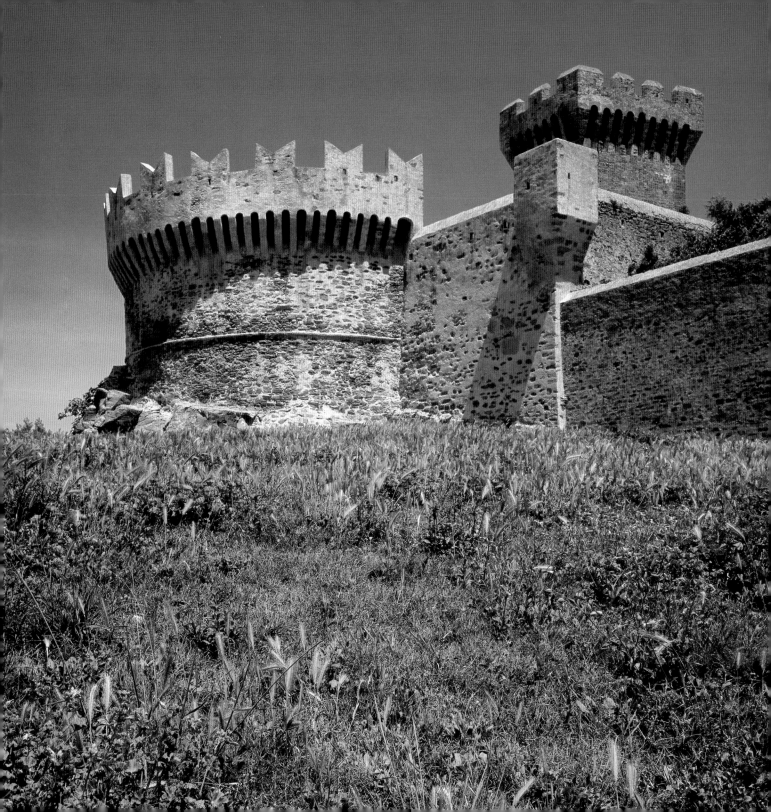

ABOVE: We arrived late on a Sunday afternoon at Cava Gioia near Colonnata with our friends in their four-by-four truck. Here, at the crest of the Alpuan Alps, is an entire mountaintop of the purest of crystalline white marble, the raw material for sculptures adorning piazzas and duomos across Italy.

OPPOSITE: From Carrara, the mountains of the Alpuan Alps glisten from the exposed white marble as though covered with snow.

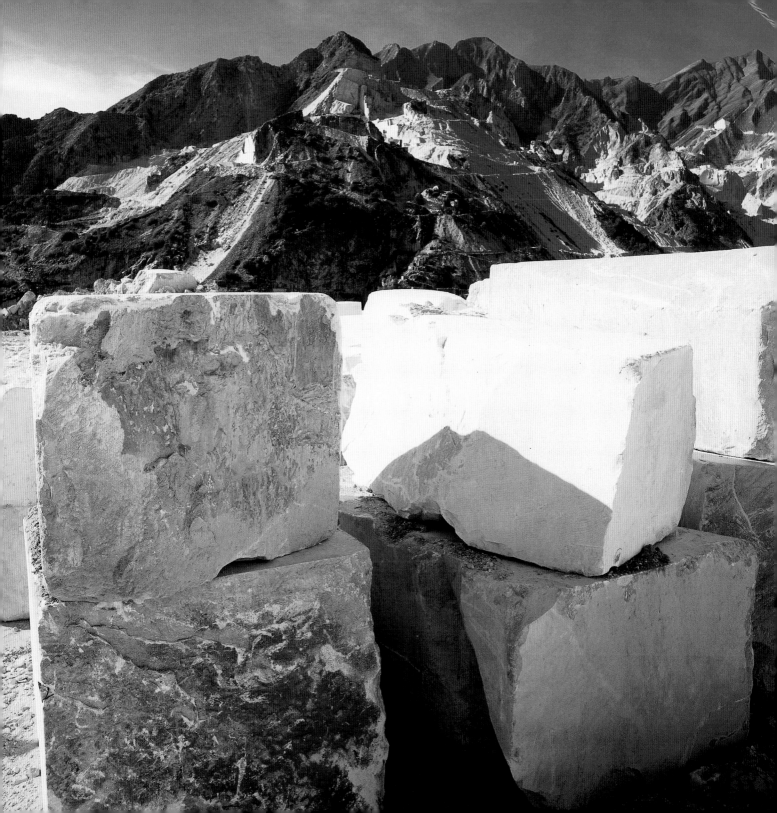

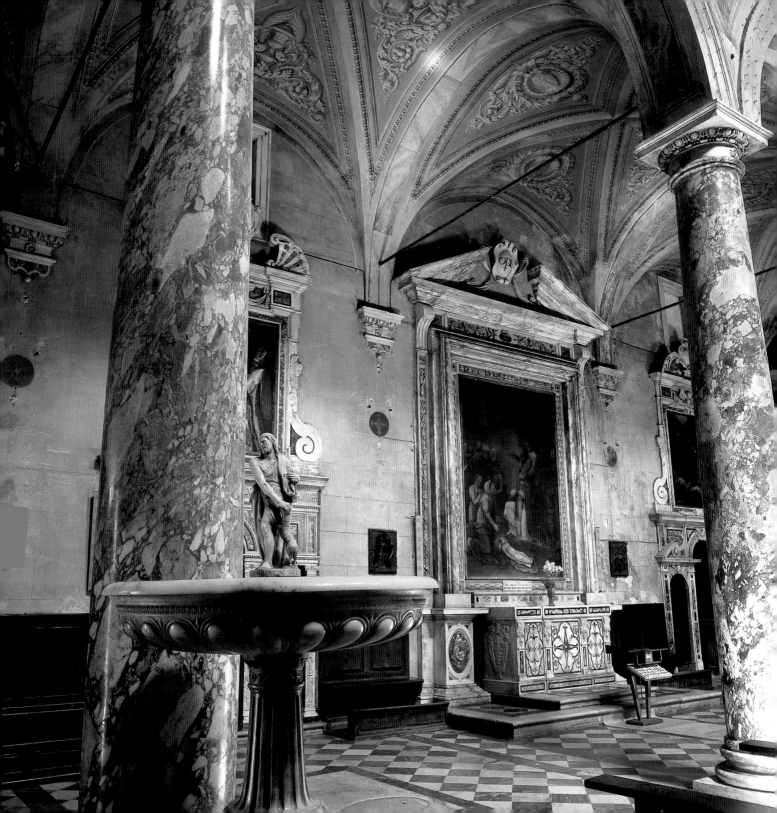

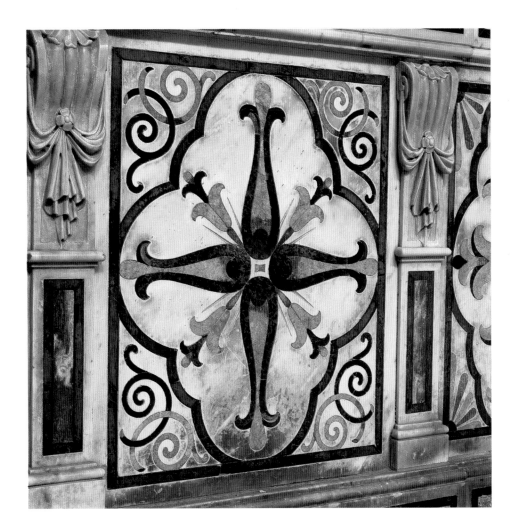

OPPOSITE: The interior of the Duomo di San Martino displays the town's beautiful local resource. Begun in 1256 and restored in 1630 and 1824, it is a masterpiece constructed from marble in every natural hue.

ABOVE: This detail on the face of a side altar in the Duomo di San Martino in Pietrasanta is adorned with a geometric marble inlay using the various natural colors of the local marble. Pietrasanta—literally "holy stone"—is home to sculptors from around the world, who are drawn to the town for its abundance of natural marble, artists' community, and bronze foundries.

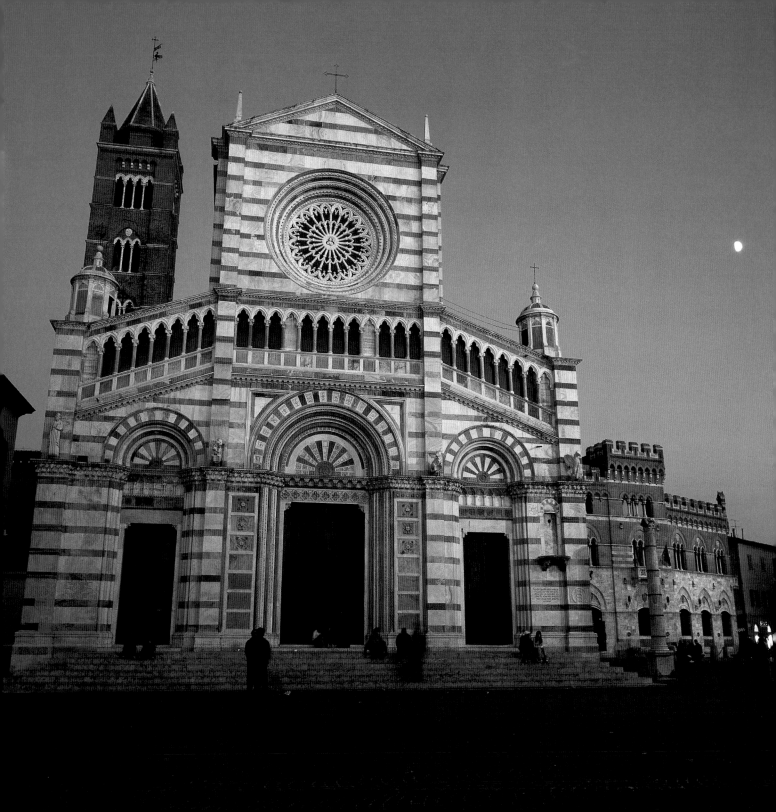

There is, in fact, no law or government at all [in Italy];
and it is wonderful how well things go on without them.

LORD BRYON

Grosseto's Duomo dominates the Piazza Dante with its imposing pink and white marble facade. The original cathedral was built toward the end of the thirteenth century over an existing church about a century old; the current facade was not constructed until 1840s. At night the piazza comes alive with locals. Try one of the its trattorias for a plate of fresh pasta accompanied by a glass of wine crafted in the Maremma.

RESOURCE GUIDE

AREZZO

Fiera Antiquaria
Piazza Grande
Monthly, the first Sunday of the month

This monthly antique fair attracts vendors from all over the country with varied antique wares that fill the piazza and spill out onto the surrounding streets.

BADIA A PASSIGNANO

Antinori Winery, Badia a Passignano Estate
Via Passignano, 33
Badia a Passignano
tel / fax +39 0558 071278
www.osteriadipassignano.com

Grown on the vineyards that surround the abbey, the Antinori Badia a Passignano estate produces the excellent Chianti Classico Riserva di Badia a Passignano, among other wines that are aged in the one-thousand year-old cellar beneath the abbey.

Osteria di Passignano
Badia a Passignano Estate
Via Passignano, 33
Badia a Passignano
tel / fax +39 0558 071278
www.osteriadipassignano.com

Allegra Antinori opened a small wine shop called La Bottega on the estate in 1995 inside an 18th century building near the abbey entrance. In 2000 the wine shop was extended and the Osteria di Passignano was opened. One of our favorites of the region, this osteria offers spectacular food served with the superb wines of the Antinori family.

BAGNO VIGNONI

La Locanda del Loggiato
Piazza del Maretto, 30
Bagno Vignoni
tel +39 0577 888925
fax +39 0577 888370
www.loggiato.com

The six-room B&B on the main square of this spa town has a breakfast room that turns into a delightful wine bar in the evening hours.

Osteria La Parata
Piazza de Moretto, 40
Bagno Vignoni
tel +39 0557 887508

Grab a hearty meal here following a soak in the baths.

BOLGHERI

Enoteca Tognoni
Via Lauretta, 5
Bolgheri 57020
tel / fax +39 0565 762001
www.enotecatognoni.it

Located in the Marema viticultural region, this is a wonderful trattoria and wine shop.

CASTELMUZIO

Il Camarlengo
info@ilcamarlengo.it

This cathedral in Pitigliano was particularly glorious in late afternoon, with sun rays passing through ancient stained-glass windows and lighting the interior in shades of lavender and gold.

tel +39 0577 665373
fax +39 0577 665984
www.ilcamarlengo.it

Housed in a 15th century tower, Il Camarlengo offers an experience of real Tuscany with its modest but comfortable accommodations and a restaurant with traditional local fare.

CASTELNUOVO BERARDENGA

Castelnuovo Berardenga Grape Festival
Annual, the last week of September

This little Sienese town is transformed for the occasion into a showcase of its ancient farming and grape growing traditions. During the festival there is an abundance of tastings, with special attention to their excellent Chianti wines. The parade is also a high point, with themes derived from the countryside and the life of the farmers, accompanied by men and women in traditional costumes.

CORTONA

Trattoria Toscana
Via Dardano, 12
Cortona
tel + 39 0575 604192
www.toscumbria.com/
trattoriatoscana/

Chef Santino offers fine cuisine in this small restaurant just off Piazza Signorelli, including *ribollita*, a Tuscan minestrone soup served over toasted bread.

Poggio al Sole
C.S. Valecchie Montanare
Cortona
tel +39 0575 614033
info@poggiosole.it
www.poggiosole.it

Quiet, peaceful, and nestled on a hillside. Chef Benedetta is a great cook—and she also teaches cooking classes.

Antique Furniture Market
August – September

Cortona hosts a national antique furniture market at the end of each summer. The small shops scattered throughout the town also offer a range of antique wares year round.

GAIOLE

L'Ultimo Mulino
La Ripresa di Vistarenni
tel +39 0577 738520
fax +39 0577 738659

A unique setting in a heavily wooded nook beside a small stream, this cozy hotel was originally a medieval olive mill.

Badia a Coltibuono
tel +39 0577 749424
fax +39 0577 749031
ristbadia@coltibuono.com
www.coltibuono.com

Great cuisine in a unique atmosphere situated in the estate's original horse stables, serving exquisite wines from grapes grown on site.

GROSSETTO

Ristorante Il Canot del Gallo
Via Mazzini, 29
Grosseto
tel +39 0564 414589

Located in a tunnel beneath the city wall, the food matches the drama of the setting—outstanding.

LUCCA

Buca di San Antonio
Via della Cervia 3
Lucca
tel +39 0583 55881
www.bucadisantantonio.com

The handmade ravioli is the stand out item on this delicious menu, served up in a warm atmosphere at one of the finest restaurants in Lucca.

Caffe di Simo
Via Fillungo, 58

San Gimignano is a much-visited shoppers' paradise. With upscale shops and skilled artisans, San Gimignano produces some of the finest jewelry, art, and fashion south of Florence.

Lucca
tel + 39 0583 496234
fax + 39 0583 496234
anticocaffedisimo@tin.it

This historical patisserie was the meeting place of Lucca's artists and intellectuals in the late 1880's, and still maintains its original ambiance. We stopped here daily for a midmorning cappuccino and pastry.

LUCIGNANO

Museo Civico
Piazza del Tribunale, 22
Lucignano
tel + 39 0575 836899
www.comune.lucignano.ar.it
lucignano@comune.lucignanoar.it

Contains a good collection of 13- to 15th-century Sienese art, including Luca Signorelli Madonna and a 14th-century masterpiece of Arentine goldsmiths, the delicate reliquary Albero di Lucignano (Tree of Lucignano).

MERCATALE VAL DI PESA

Castello di Gabbiano
Mercatale Val di Pesa
tel / fax + 39 0558 218423
www.gabbiano.com

There are several buildings on the Castello di Gabbiano estate that have been renovated for accommodations. In July 2006 accommodations were made available in the castle, the most beautiful and magical building on the estate, with rooms once occupied by the most prestigious of Florentine families.

MONTEBENICHI

Castelletto di Montebenichi
Localitá Montebenichi
Bucine, Arezzo
tel + 39 055 9910110
fax + 39 055 9910113
info@castelletto.it
www.castelletto.it

We were very pleased with this incredible hotel that houses precious works of art, including period frescoes, precious archeological finds, sculpture, and antique paintings and drawings in its elegant rooms.

MONTEFIORALLE

La Castellana Ristorante
Via di Montefioralle, 2
Montedioralle
tel + 39 055 853 134
Walking through the village of Montefioralle is like taking a step back in time. La Castellana Ristorante is an excellent break on your walking tour, offering classic Tuscan cooking with an excellent view of the surrounding countryside.

MONTICCHIELLO

Osteria La Porta
Via del Piano
Monticchiello di Pienza 53026
tel / fax +39 0578 755163
www.osterialaporta.it
osterialaporta@valdorcia.it

Located right near the entry gate of Monticchiello, this small osteria is run beautifully by Daria, the young owner. For spring and summer, a table on the terrace cannot be beat.

PANZANO

Villa le Barone
Via S. Leolino, 19

Radicofani is a landmark of southern Tuscany, set high on a cliff and topped by the lofty tower pictured here. The tower—part of a ruined fortress surrounding the village—was fought over historically by the pontifical state, the Republic of Siena, and Florence. In the thirteenth century, as narrated by Dante in *The Divine Comedy* and Boccaccio in *The Decameron*, the famous bandit Ghino di Tacco took possession of the fortress, where he remained for three years. Today, if the weather is clear, it offers you a spectacular view of Mount Amiata, the Chiana Valley and Umbria, Lake Bolsena, and the central Appennines. Before you head into the village, it's worth taking a walk in the pine forest that surrounds the fortress.

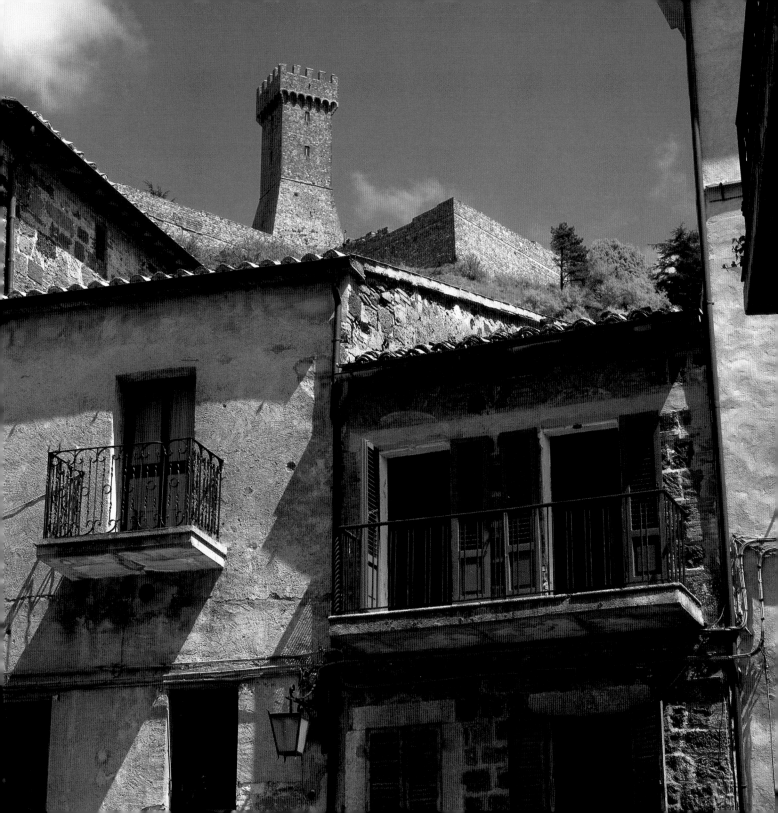

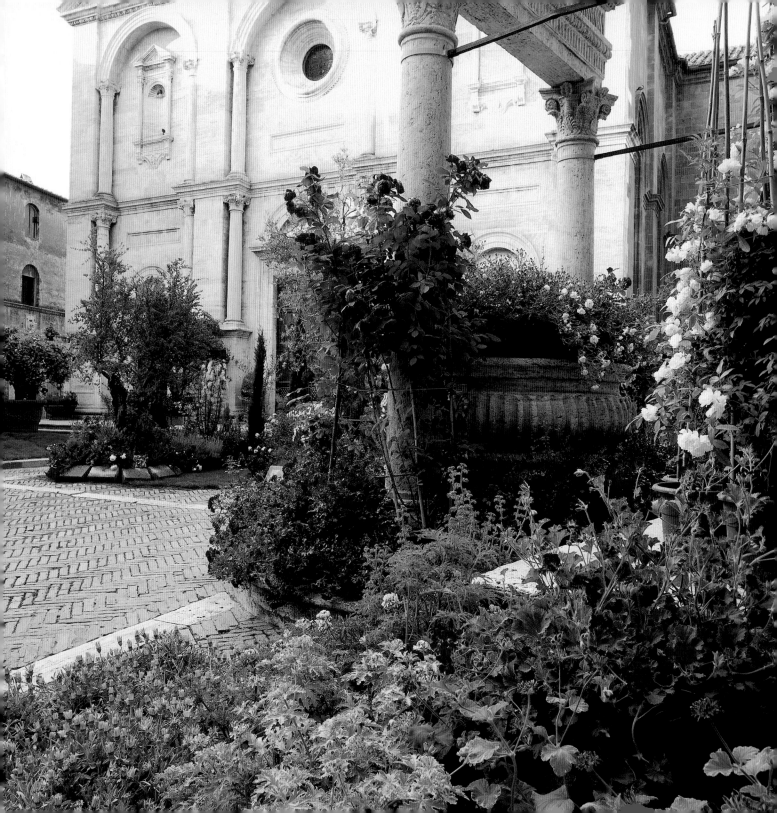

Panzano
tel + 39 055 852621
www.villalebarone.it

This 16th-century villa is owned by
the famous della Robbia family, and
is elegant and intimate. A great home
base for visiting the Chianti region.

PERGO

Agriturismo Poggio al Sole
Via San Pantaleo, 145
Vinci
tel + 39 057 156 021
www.agriturismopoggioalsole.it
info@agriturismopoggioalsole.it

Each of the apartments on this
agriturismo has been named after a
wild flower of the Tuscan countryside,
and is set on a hill surrounded by
woods of wild cherry and walnut trees,
olive groves, and vineyards which
produce high quality wines and oil.

PIENZA

Azienda Agricola San Polo
Pienza
t +39 0577 665321
ernarm@tin.it

This farm produces one of the best
pecorino cheeses in Tuscany. We were
welcomed warmly by the wonderful
hosts here who opened up their farm
to us.

Agriturismo Terrapille
Terrapille
53026 Pienza
tel + 39 0578 748434
www.terrapille.it
terrapille@bccmp.com

This beautiful farm is situated on a
hill facing Pienza and is surrounded
by a panorama of the Val D'Orcia. We
went on many excursions throughout
the countryside with our hosts
Giuliano, Elsa, Lucia, and Ilyas. The
accommodations themselves were
built from local tufa and maintained
beautifully.

La Buca delle Fate
Corso Rossellino, 38
Pienza
tel + 39 0578 748272
fax + 39 0578 748272

Buca delle Fate (literally "Hole of the
Fairies," a mysterious name that recalls
an ancient Etruscan structure in the
area) serves all the local specialties,
including pici which is one of the
classical poor dishes of the Tuscan
country kitchen, a pasta made with a
mix of water and flour and of a touch of
oil and salt.

SCANSANO

La Cantina
Via della Botte, 1
Scansano
tel + 39 0564 507605

This cozy restaurant and wine bar
offers a selection of various local olive
oils to taste with your meal.

SAN CASCIANO VAL DI PESA

Fattoria Corzano e Paterno
Via Paterno, 10
San Pancrazio
tel + 39 0558 248179
www.corzanoepaterno.it

This large farm produces fine wine,
olive oil, and sheep cheeses, and offers
stunning accommodations in its rural
setting.

Pienza is a gem of a Renaissance village set amid some of the most breathtaking and archetypal of Tuscan landscapes. The
tiny, orderly town hosts a flower festival each summer. Architect Bernardo Rossellino designed the village, with the original
intent for it to extend over the surrounding Tuscan hills, but funding—which was raised by the followers of Pope Pius II, who
was determined to raise a city there, where he was born in 1405—soon ran out. Piazza Pio, the heart of the village, reveals
something of the elegant and simple original design intention.

Published in 2007 by Welcome Books ®
An imprint of Welcome Enterprises, Inc.
6 West 18th Street, New York, NY 10011
(212) 989-3200; Fax (212) 989-3205
www.welcomebooks.com

Publisher: Lena Tabori
Designer: Naomi Irie
Project Director: Natasha Tabori Fried
Editorial Assistants: Kara Mason, Maren Gregerson

Library of Congress Cataloging-in-Publication Data

Walker, Wes.
Tuscan country : a photographer's journey / photographs by Wes
Walker.
p. cm.
ISBN 978-1-59962-022-0 (alk. paper)
1. Tuscany (Italy)--Pictorial works. 2. Tuscany (Italy)--
Description and travel. I. Title.
DG734.4.W35 2007
945'.5--dc22

2006034745

Printed in China

First Edition
10 9 8 7 6 5 4 3 2 1

Text Credits:
"Canti Toscani: Part II, IV" by Lawrence Ferlinghetti, from
European Poems and Transcriptions, copyright © 1980 by Lawrence
Ferlinghetti. Reprinted by permission of New Directions
Publishing Corporation; Selections from *The Hills of Tuscany*
by Ferenc Máté. Reprinted by permission of Ferenc Máté and
Albatross Publishing; Selection from *Under the Tuscan Sun* ©
1996 by Frances Mayes. Used with permission of Chronicle Books
LLC, San Francisco. Visit ChronicleBooks.com; Selection from *The
Tuscan Year* by Elizabeth Romer. Copyright © 1984 by Elizabeth
Romer. Reprinted by permission of Georges Borchardt, Inc.,
on behalf of the author; Brief selection from *Italy: The Places in
Between, Revised and Expanded* by Kate Simon, copyright © 1970,
1984 by Kate Simon.

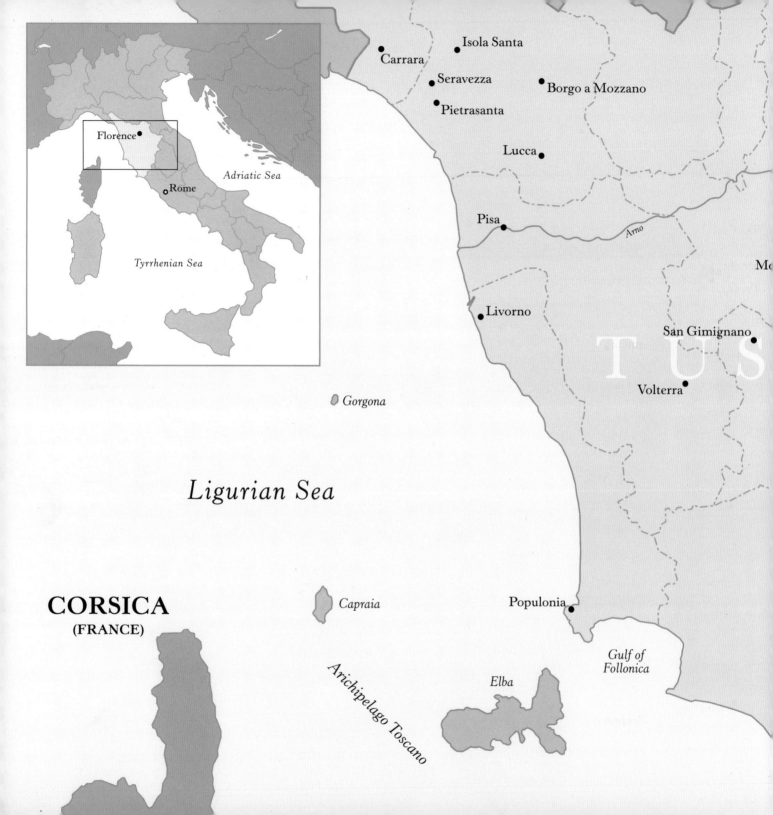

Isola Santa

Carrara

Seravezza

Borgo a Mozzano

Pietrasanta

Florence

Adriatic Sea

Lucca

Rome

Pisa

Arno

Tyrrhenian Sea

Mo

Livorno

San Gimignano

TUS

Volterra

Gorgona

Ligurian Sea

CORSICA
(FRANCE)

Capraia

Populonia

Gulf of
Follonica

Elba

Arichipelago Toscano